BEDWORTH
THROUGH TIME
John Burton

John Burton

AMBERLEY PUBLISHING

For Lynda, as thanks for her love and support

First published 2014

Amberley Publishing
The Hill, Stroud, Gloucestershire, GL5 4EP
www.amberley-books.com

Copyright © John Burton, 2014

The right of John Burton to be identified as the
Author of this work has been asserted in accordance with
the Copyrights, Designs and Patents Act 1988.

ISBN 978 1 84868 753 0 (print)
ISBN 978 1 4456 3729 7 (ebook)

British Library Cataloguing in Publication Data.
A catalogue record for this book is available from the
British Library.

Typesetting by Amberley Publishing.
Printed in Great Britain.

Introduction

Technology has made rapid strides in recent years and it is now possible to produce full-colour books at a reasonable cost, so I was delighted to have the opportunity to use some of my colour slides taken since 1970 in this book. Slides and prints lose their colour over the years. They turn magenta or blue, or even fade away in a most disconcerting manner, especially when we know that black-and-white negatives have already shown their ability to survive for a century. This book is in part a chance to preserve my own images before they fade away, by restoring their colour and converting them to a digital format. No one knows how long digital images will last, but they will certainly outlive me.

Some of the pictures I took when I first moved to Bedworth in 1968 show the town in a state of change. Market Street had mostly gone, and the Market Place was soon to go, followed by Leicester Street, High Street and King Street, so that by the end of the 1970s the old town had almost disappeared. Bits of Mill Street remain, as do some churches and the Almshouses, but the fifteen years from 1965 saw extraordinary changes that were disconcerting to people born and bred in the town. Market Street and Market Place lost their names and shapes, and Church Street disappeared without trace. Local government reorganisation in 1974 even removed the name of the town from its governing local authority, an insensitivity that was later remedied.

Many of the buildings demolished during those fifteen years were in poor repair; they were cramped and overcrowded and to retain them, restore them and make them suitable for late twentieth-century use demanded more inspiration, dedication and passion than was then available to the decision-makers in local government. There is one exception to this broad generalisation. The Nicholas Chamberlaine Almshouses came perilously close to demolition in the mid-1970s. The subsequent restoration over a twenty-year period from the mid-1980s

is the best piece of architectural activity to have happened in the town in the last forty years. Just as Astley Castle has been given a new life by an inspired team, so too have Bedworth Almshouses been given a future after some inspired decisions by their governors. Astley won the Stirling Prize in 2013. Bedworth Almshouses deserve praise from all our local residents.

For the rest, the rebuilt Bedworth frequently looks shabby, especially now that the local authority cannot afford the wonderful floral displays that were a feature of the 1990s and early years of the twenty-first century. There is no architectural merit in the rebuilt town, apart from in High Street where the Civic Hall, the library, the police station and health centre are good new buildings. The new Tesco store is far too large for Bedworth and there aren't enough well-heeled people in the town to support independent food outlets that would help to keep the place alive.

Our way of life has changed dramatically in the last generation and I hope that the selection of photographs in this volume will be a reminder of how we used to live. I have had to leave out huge areas of Bedworth life but, if this volume is successful, I hope a companion one will cover things like schools, churches, entertainment and some of the streets and roads not included here.

I HAVE JUST ARRIVED AT BEDWORTH

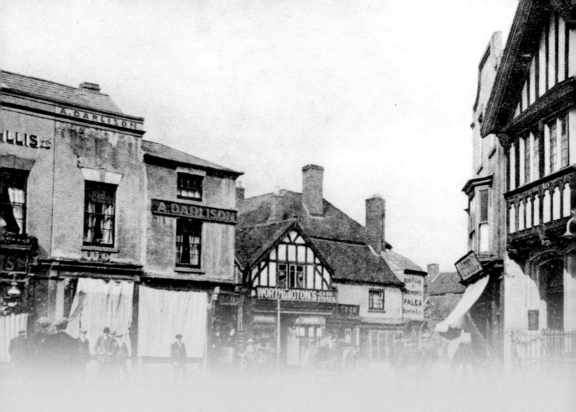

CHAPTER 1

All Saints Square

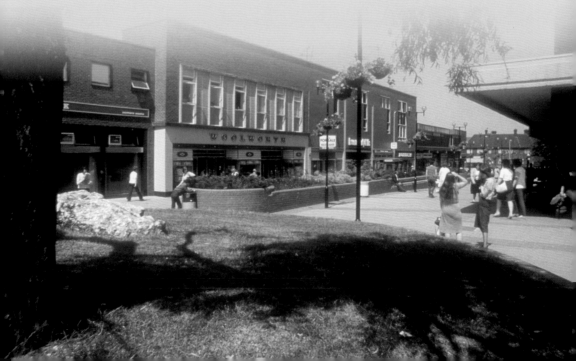

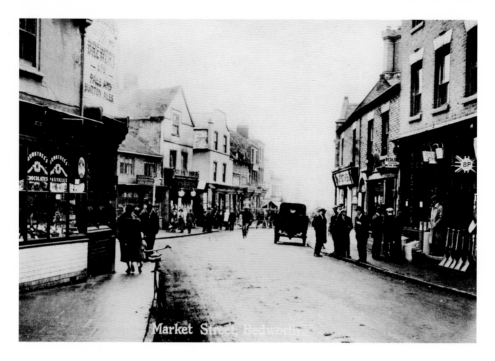

Market Street

The picture at the top of page 5 shows the view from King Street across to what was then called Market Street but is now All Saints Square. The lower picture shows the equivalent view in the 1970s, before the demise of Woolworths. On this page, we see Market Street looking towards Market Place. The ladies are at work in Worthington's in the 1960s. They are Lily Bettam, Gladys Haywood, Olwyn Randle and Doris Mortiboys.

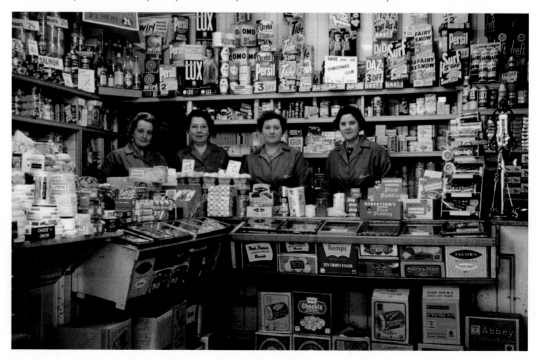

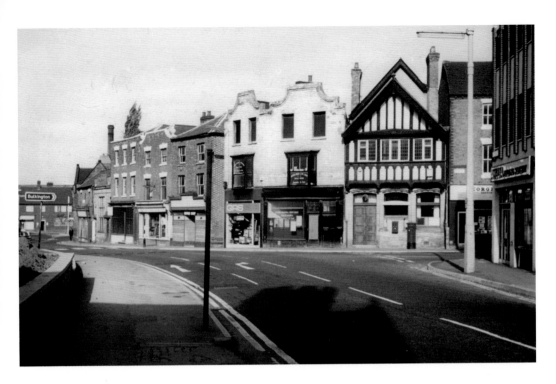

Market Street

These pictures show the opposite side of the road at the top of Market Street. There used to be an angle in the road where Market Place became Market Street. That all disappeared when the dull, rectangular All Saints Square was created and made traffic-free, something that could only happen when the bypass and Rye Piece Ringway were created. The top picture was taken in 1970.

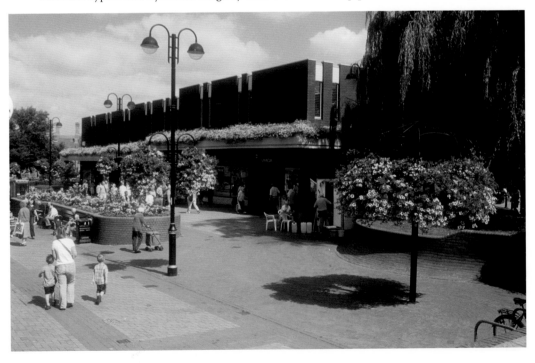

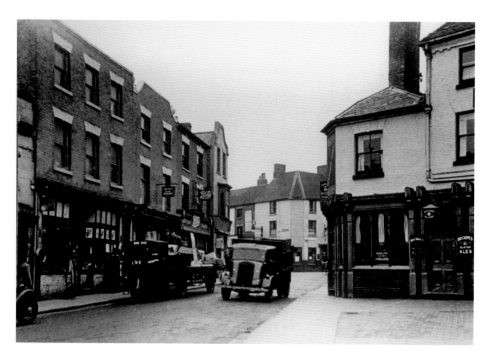

Market Street

The pictures show the same spot. The top picture on this page dates from 1948. It was taken from the same place as the children are in the bottom picture, which dates from 1914 and shows just two of more than fifty pubs and clubs in the town at that time. With redevelopment, both The Newdigate Arms and The Bull were relocated to out of town sites. Church Street goes off to the right behind the girls.

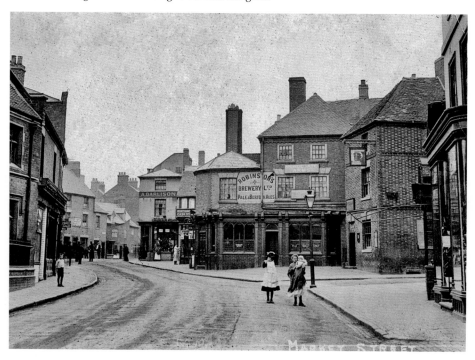

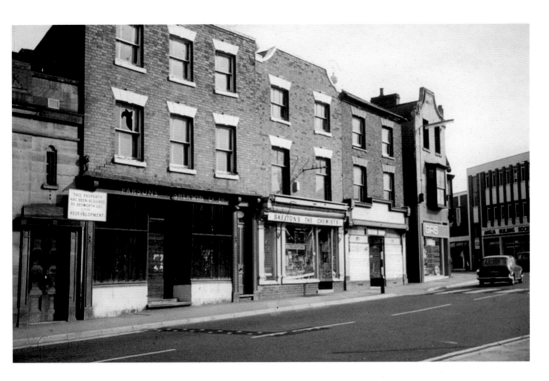

Market Street

The same line of shops above, but taken in 1970. On the left had been Barclays Bank, then Parson, Sherwin & Co. and Skeltons the Chemist. Originally, the shop was owned by Mr Oates, a keen amateur photographer in the early 1900s. Through marriage, the shop changed to Skeltons, but the mosaic doorstep remained until demolition. The bottom picture shows the same view in 2013.

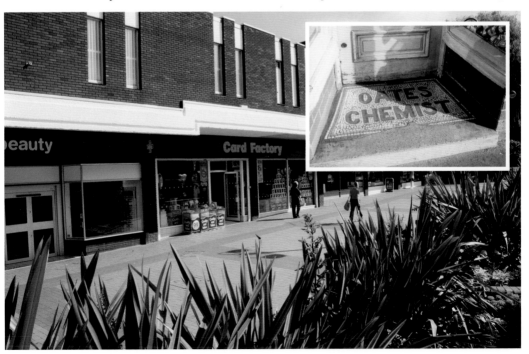

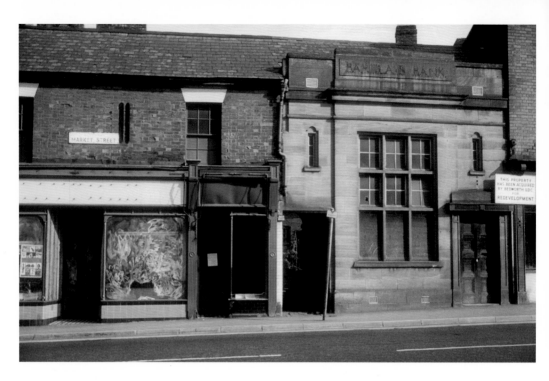

Market Street

The picture above shows the 1920s stone front created to satisfy the self-esteem and respectable solidity of the bank, which opened full-time on the day the General Strike started in 1926. Business was slow. Go down the passageway between the buildings, as I did in 1970, and what it revealed is shown below. Boots the Chemist stands there now.

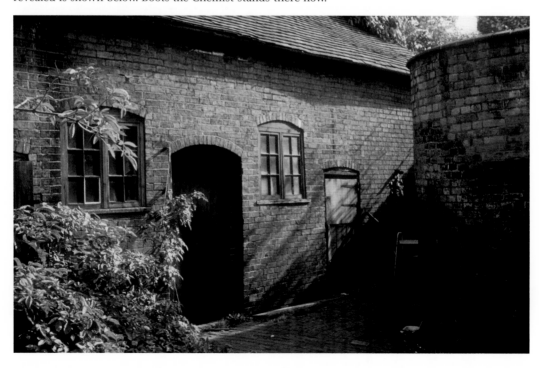

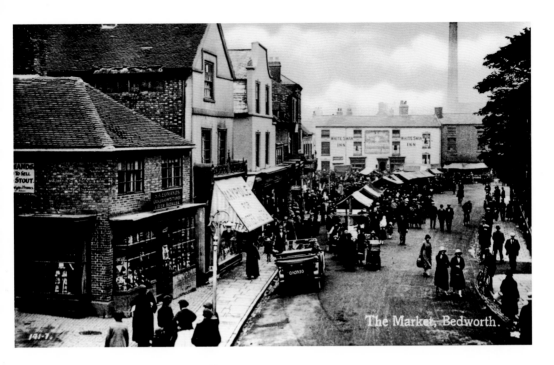

The Market, Bedworth.

Market Place and Congreve Walk
The top picture is looking in the opposite direction from the earlier ones. Market Street changes to Market Place. For a century, the market was held in the street, as we see in this shot taken from an upper room of the Newdigate Arms around 1925. There was a yard up to the left on the other side of the canopy, which later became Congreve Walk, shown below with its Brutalist concrete pillars. They have now gone and the walk is open to the elements.

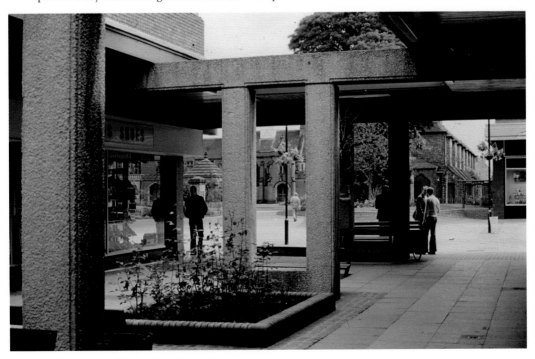

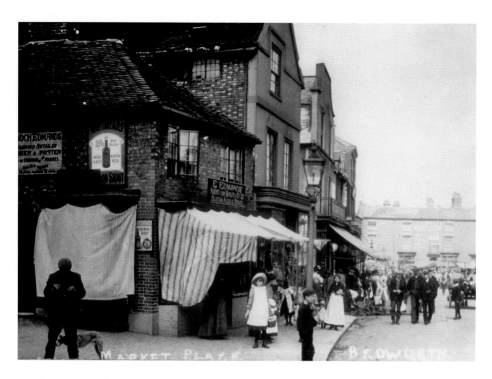

Market Place and Bunney's

The top picture shows a corner shop around 1914, which was owned by Enoch Edmands. Later, his son ran the business and expanded the range of beer and spirits to include grocery and general supplies. The lower picture shows the same building some thirty years earlier when the Darlison family owned it.

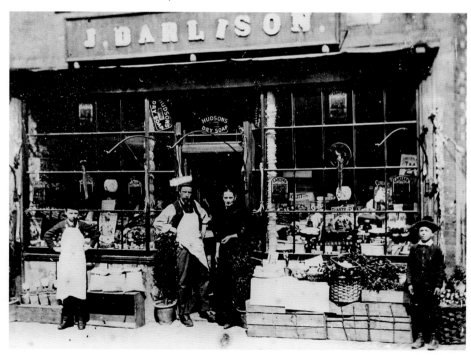

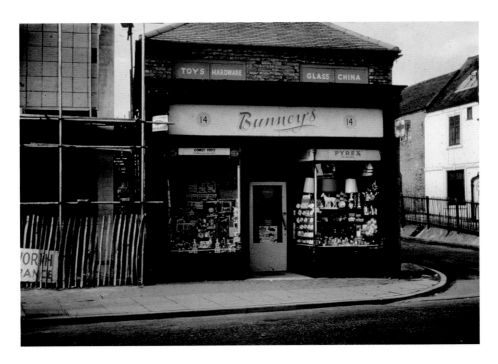

Bunney's

The same building was later taken over by the Bunney family, one of several shops they ran. The picture above was taken in the late 1960s and shows the replacement building nearing completion on the left. When finished, Bunney's moved in and Congreve Walk was constructed. It was a popular shop. Owners and brothers Derek and Don Bunney are shown here in the Heritage Centre in front of items sold at their shop. Derek died in 2012.

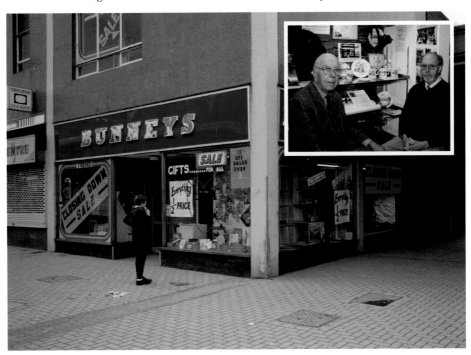

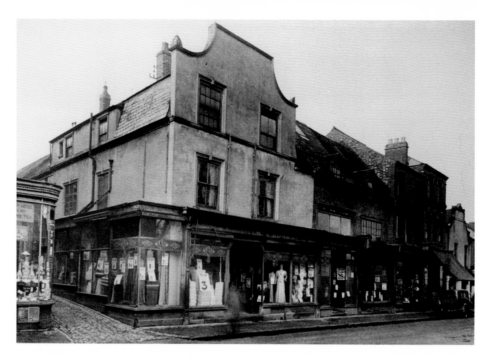

J. C. Smith's

Smith's was one of the most popular shops in Bedworth. It was originally a family business, an early department store, based in Stratford. Early in the twentieth century, they expanded to Bedworth and Nuneaton. This picture is from the 1920s, and over the years they expanded into neighbouring premises. They sold everything, at competitive prices, and had a flourishing tailoring department. The same site is shown below in 2008, when the Borough in Bloom meant exactly that.

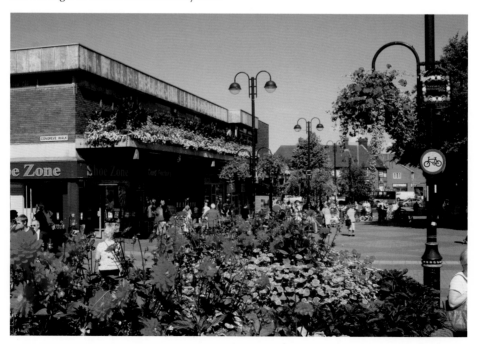

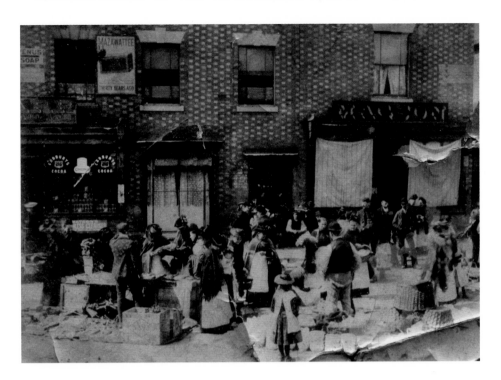

The Market

Bedworth Market is not the ancient charter-driven event that Nuneaton enjoys. It is probably less than 150 years old and was very much an ad hoc event in the 1890s when even the sophistication of a covered stall was unavailable. The town apparently needed a designated market space away from traffic. When that became a covered market in 1996, the stalls moved back to what is now All Saints Square during its construction.

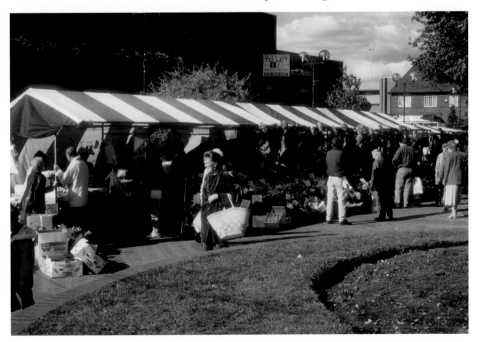

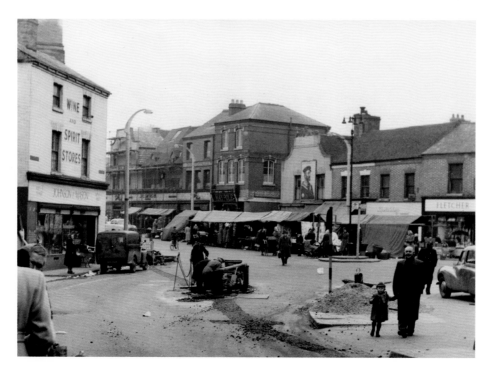

Market Place and All Saints Square

The top picture is looking into the Market Place in the 1950s. J. C. Smith's owns most of its block, apart from the maypole. It is market day and the road is up. Below we see the same shot today. The off-licence has gone, to reveal the Parsonage, part of the Almshouses, and traffic is not allowed into the shopping precinct.

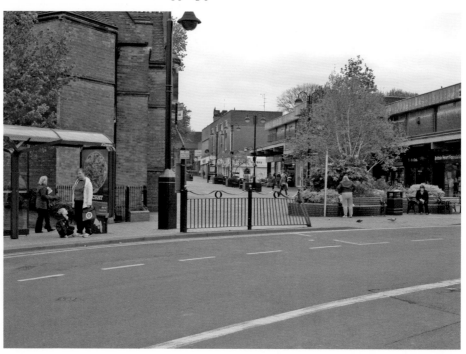

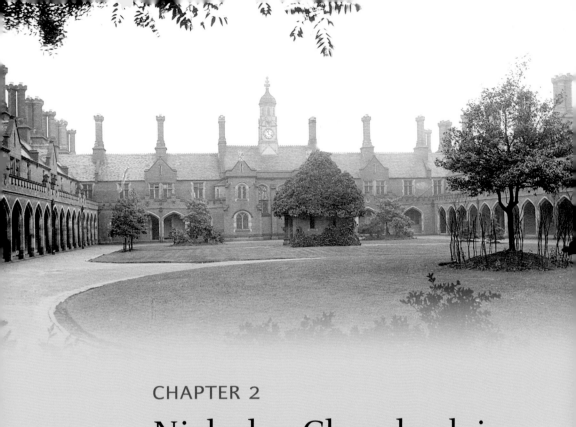

CHAPTER 2

Nicholas Chamberlaine
Almshouses

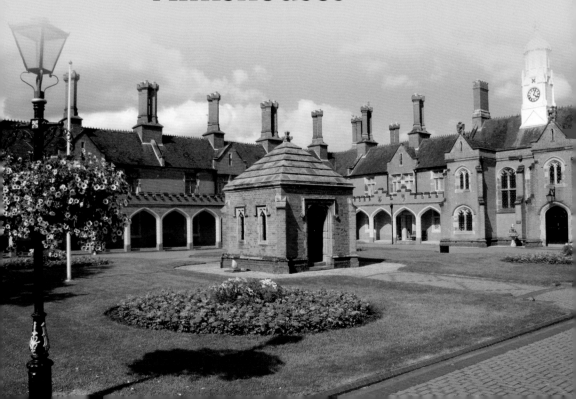

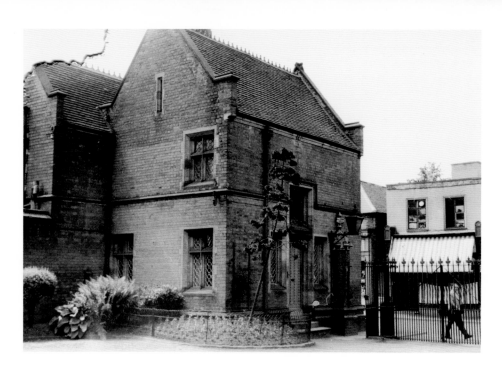

The Lodge at Bedworth Almshouses

Pictures of the Lodge are rare, so I am grateful to Maureen Chapman for this view of the Lodge taken from inside the Almshouse site and looking through the gates. The master or warden lived there, locked the gates at night and ensured that inmates wore their uniform when they went into the town. The other picture shows Marion Morris (now Kiteley), with lodge keeper Mr Dodds and the curate's son and dog, around 1936.

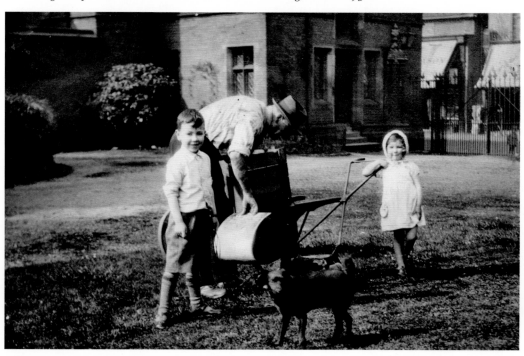

The Inside of the Almshouses

By the 1970s, many of the twenty terraced tenement residences were uninhabitable. The Almshouses were not listed until Revd Stephen Ensor was alerted to proposals for demolition and English Heritage (not then its name) intervened. Each tenement had two bedrooms, a shared living room for the two residents, and basic scullery and washing facilities. The pictures show conditions in one of them in the late 1970s. The inset shows the interior of the pumphouse in the centre of the quadrangle, shown on page 17.

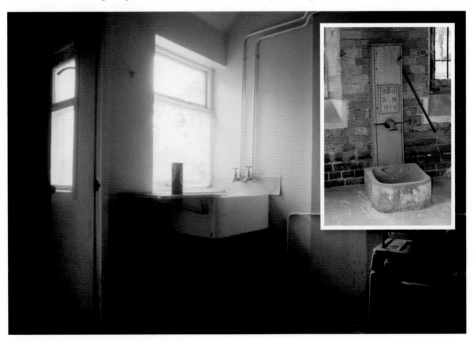

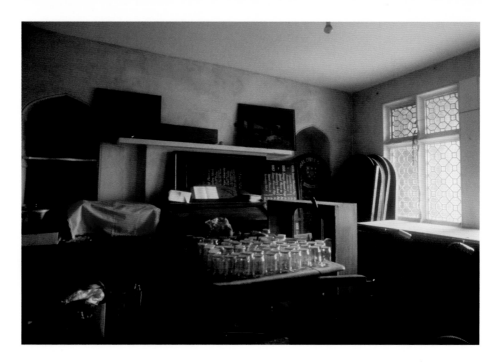

Early Use of Almshouse Space

The room above is now the residents' lounge, called the Henry Bellairs Lounge after the rector and governor in 1840. When the picture was taken in the late 1970s, it had originally been a sickroom, then a porter's room. The bottom picture is the Rector's Room, on the floor above the lounge. For many decades much of Bedworth was run from this room, until the parish council gave way to the borough council and Church influence declined.

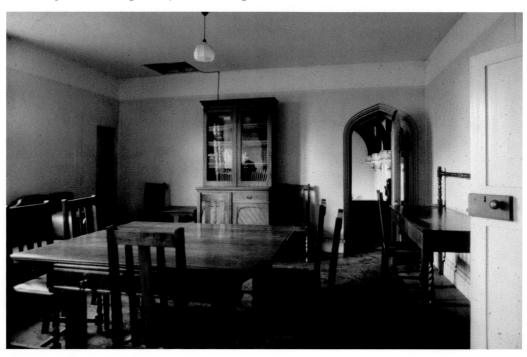

Restoration of Bedworth Almshouses

The top picture, taken in 1970, shows how run down the Almshouses were. Many of the lean-to bits have now gone, and this is a pleasant paved and maintained walkway, garden and car park for residents. Below we see the governors and officials responsible for the twenty-year restoration programme in front of a plaque in 2003. It was a major achievement, and recognition that Bedworth has an important history.

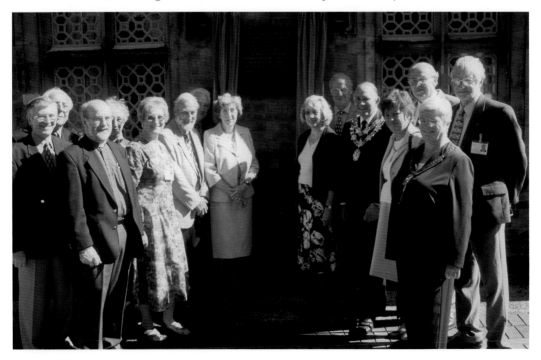

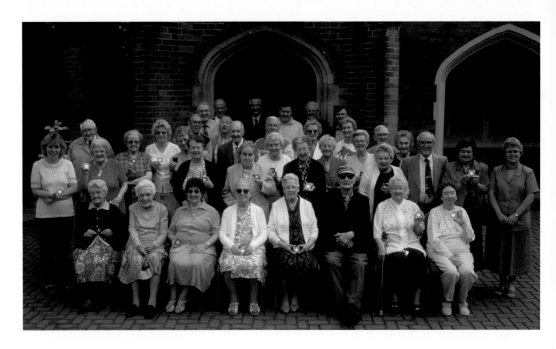

Residents of Bedworth Almshouses

Residents are no longer known as inmates and obliged to wear their uniforms when in the town; neither are they expected to attend church, nor even to have been born in Bedworth. The old tenement houses are now centrally-heated flats with modern kitchens and bathrooms. Above is a photograph of most residents in 2002, taken to mark the 50th anniversary of the Queen's accession. Below, a Central School pupil politely receives a bun on Founder's Day in the 1950s.

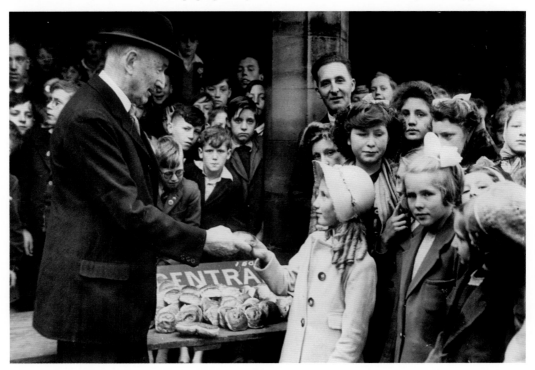

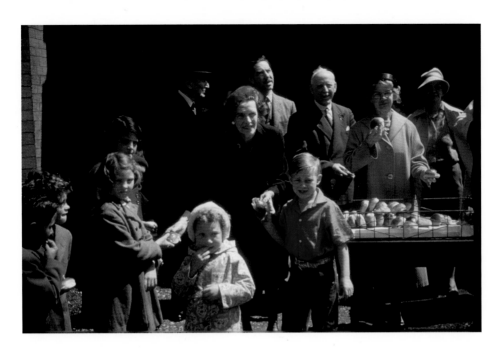

Special Events at Bedworth Almshouses

Founder's Day commemorates Nicholas Chamberlaine, rector of the parish from 1664–1715, who left money for the Almshouses and schools. Originally, each child and resident had a meal in his honour, but after 1864 a bun was substituted for the meal, hence its colloquial name of Bun Day, traditionally held in Whit Week. Here, Mrs Fitzroy Newdigate gives buns away in 1959, and below, Lady Rose Daventry (patron) witnesses a tree planted by Mayor and Chairman of Governors Cllr John Haynes, to denote the Queen's Diamond Anniversary in 2012.

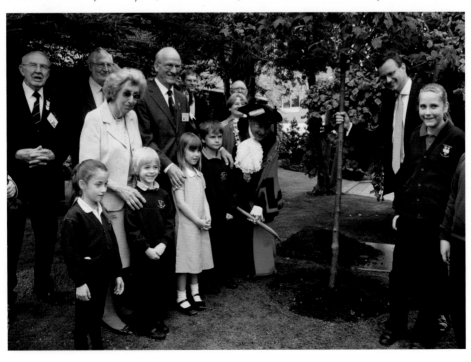

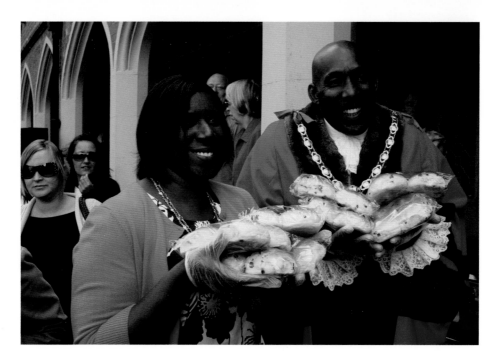

The Mayors Attend Bun Day

All the children from the four church schools in the town come to the Almshouses for a special service of thanks for the life and generosity of Revd Nicholas Chamberlaine. Traditionally, the MP and Mayor for the year attend and help to distribute the buns. In 2010, Cllr Don Navarro and his wife Josephine were there, and the following year Cllr Neill Phillips and his wife Caroline did the honours.

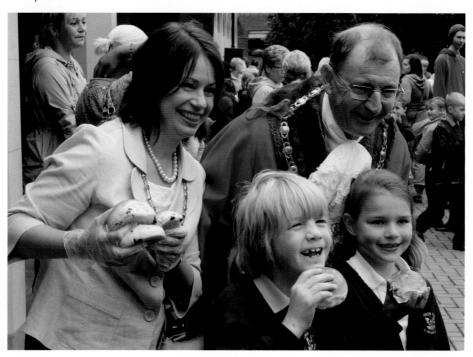

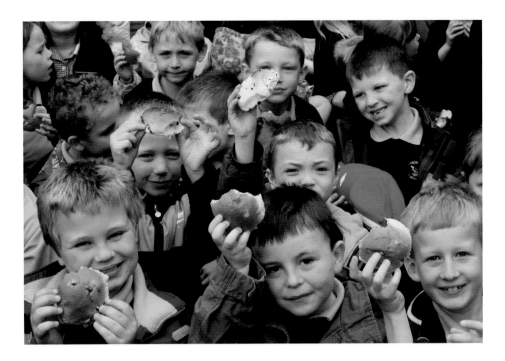

Bun Day at Bedworth Almshouses

The press love Bun Day. It is full of wonderful photograph opportunities of children eating buns. But it is also an important aspect of the town's history, and something unique to Bedworth. The top picture dates from 2008 and the bottom picture shows mostly Canon Evans Infant School children in 2012.

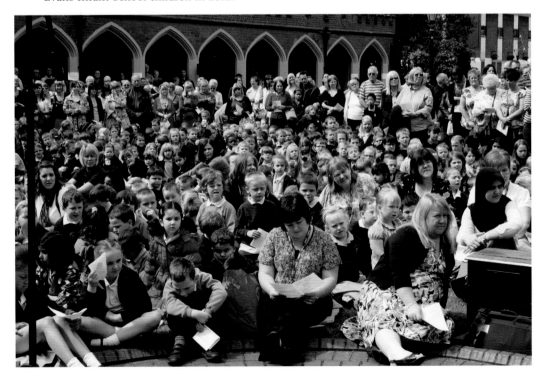

Bedworth Almshouses

The Governors' Dining Room is amazing. Designed to look like a medieval hall, it has coats of arms of over sixty earlier governors round the walls and a minstrels' gallery, and is ideal for small functions. It is still used by the governors for their meetings. The bottom picture shows the old gates and railings as they were in the 1960s. The two spades were used by the Prince of Wales in 1934 and the Duke of Gloucester in 1988 to plant trees.

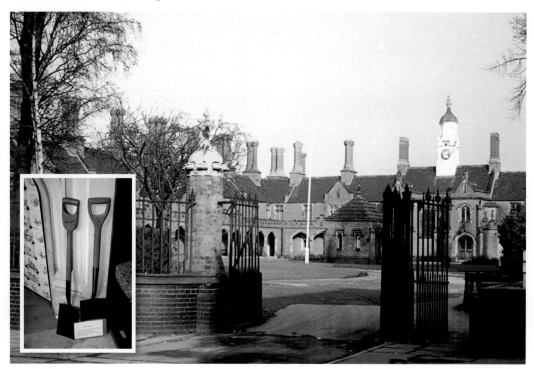

CHAPTER 3

Leicester Street

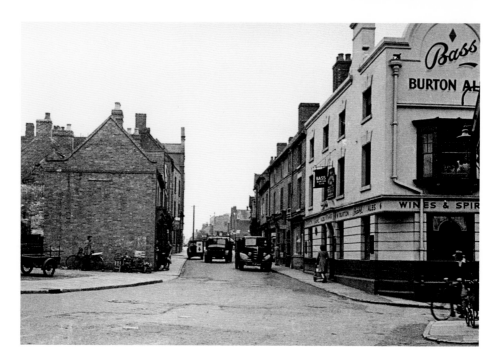

Bottom of Leicester Street

Where once there were pubs, now there are coffee shops. The White Swan on page 27 was rebuilt in the 1930s on the site of an earlier White Swan. Its near neighbour on the corner of Leicester Street, The New Inn, stood where the empty space is on the left of the picture above. All the buildings shown above have gone. The inset shows Cadman's bakery. The shop was incorporated into the Hit or Miss Inn around 1906.

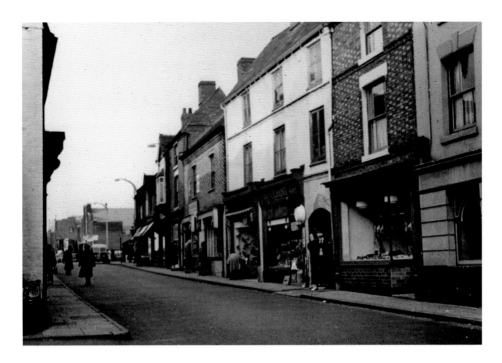

Bottom of Leicester Street

The Leicester Street redevelopment took place as the Market Place/All Saints Square scheme finished. It was largely completed during the mid-1970s on the east side of the street, and by 1980, the west side mostly comprised a lumbering Tesco, which was itself replaced by an airier store thirty years later. The twin-gabled building in the picture below is the headquarters for Domestic & General.

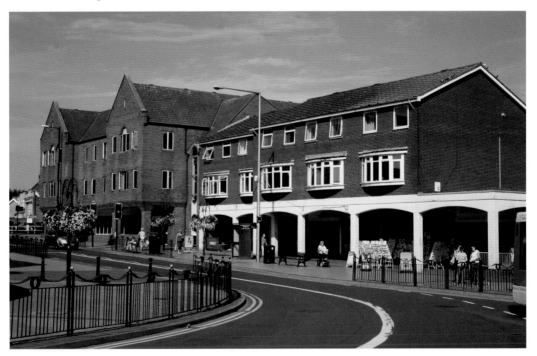

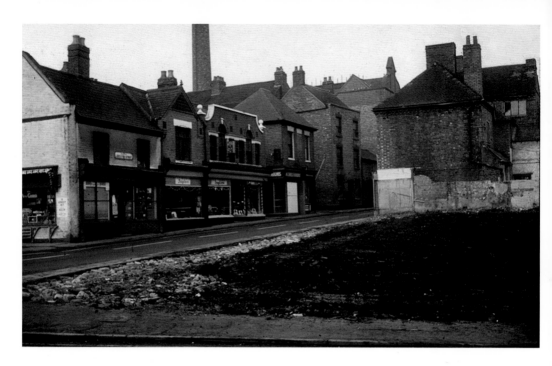

Bottom of Leicester Street

Only four years separate these pictures. In March 1973, the Hit or Miss pub had gone, allowing a view of nineteenth-century Leicester Street. In the distance is Pickerings hat factory and chimney, though latterly it had been Clear Hooters, component manufacturer for the Coventry motor industry. The lower picture, taken in June 1977, shows the new building on the pub site, and demolition of the factory site nearing completion.

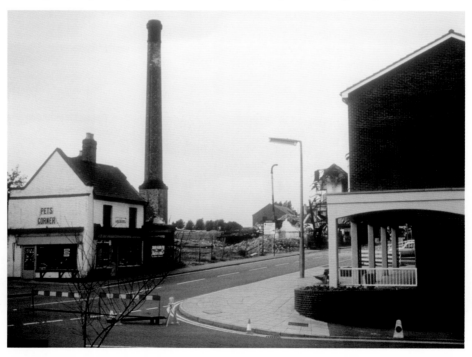

Bottom of Leicester Street

The Tesco store shown above was built in 1980 and was a remarkably solid building. Bede Arcade never really worked as a set of small starter units. Below, the same scene four years later in 2012 shows the converted Bede Arcade as flats and three shop units, and the much enlarged but less architecturally oppressive new Tesco.

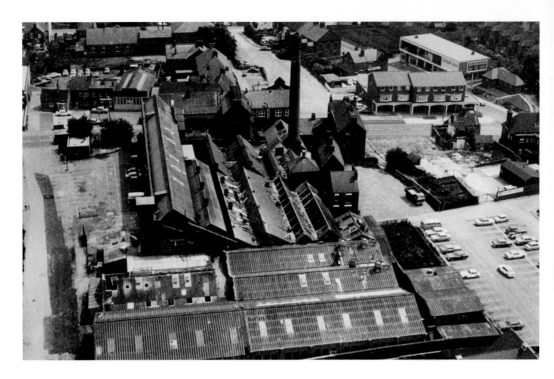

Leicester Street and Pickerings Factory

The aerial picture shows Leicester Street in transition. The Hit or Miss has been replaced by a new block of shops and flats, and in 1976 the huge factory site was awaiting demolition. The picture below was taken in 1970 and shows the factory frontage. On the left are The Hatters Arms and two cottages that had been empty for years.

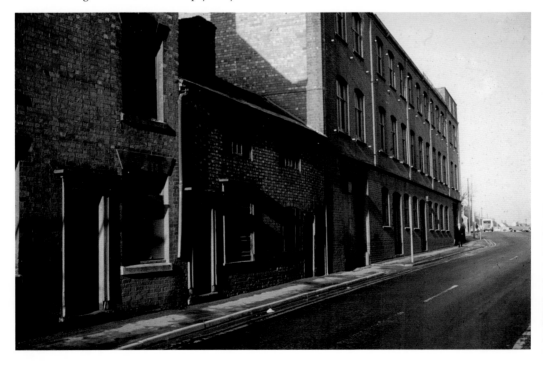

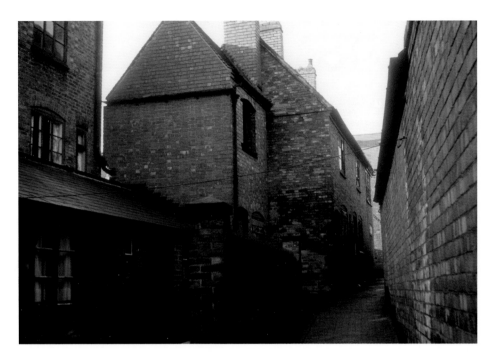

Leicester Street and Pickerings Factory

Between the cottages shown opposite and the factory wall was a passage, shown here. It was a gloomy outlook for residents in the houses facing the factory wall, as well as those pointing north. The passage came out at the top of Sleaths Yard. The passage between Tesco and the Bede building is in much the same spot now. The picture below shows Hatters Yard in 1971, and the inset shows the old Hatters Arms and yard in January 1976.

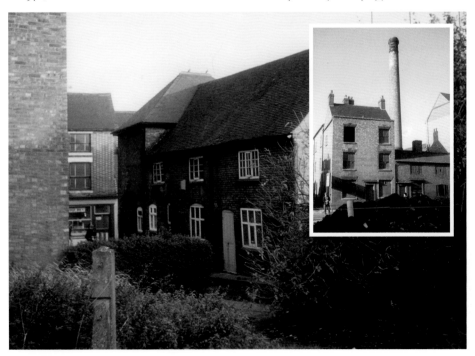

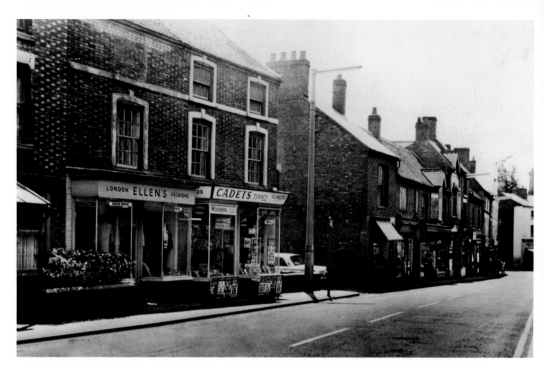

Leicester Street

The east side of Leicester Street is shown in the mid-1960s. The photographer was outside Pickerings factory and the car is parked in Old Meeting Yard. I took the bottom picture in 1978. Off the picture to the left was Payne's coach company. The shop site is now a car park for Domestic & General.

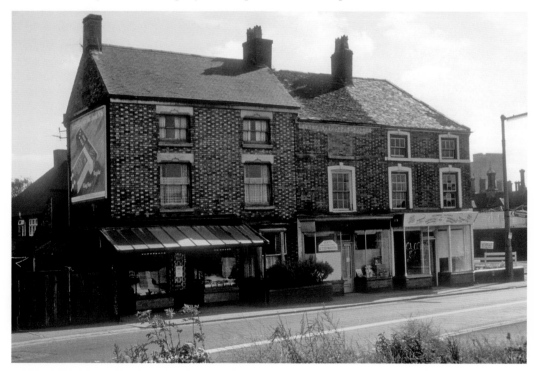

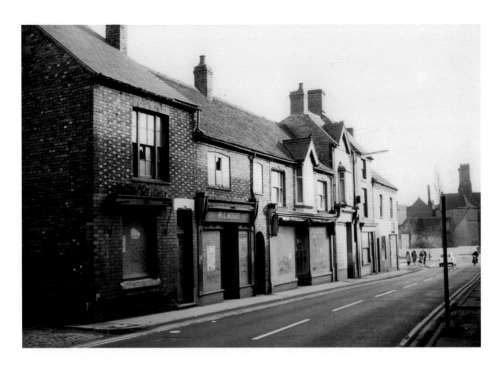

Leicester Street

This line of shops was awaiting demolition in 1975. Mr Moore's grocery shop was on the corner of Old Meeting Yard. There was a narrow passageway to the right of his shop – Wyatt's Yard, shown below in 1948. The cottages, with outside loos, stretched down as far as the Old Meeting church. Ron and Margaret Harris started married life in one of these cottages. They had to saw the bed in half to get it upstairs!

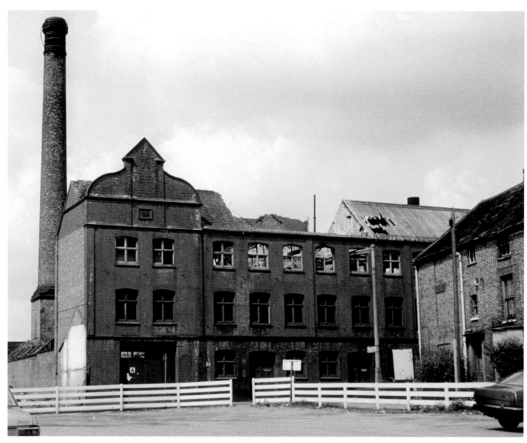

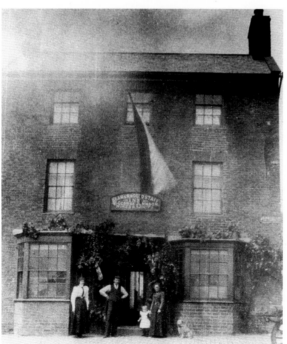

Leicester Street and Pickerings Factory

By May 1977, Wyatt's Yard had gone and the space became a temporary car park. The factory was derelict and had been subject to attack by vandals. One fire filled the town with smoke. This picture shows the damaged roof the following morning. Further up the street, as Leicester Street becomes Leicester Road, is a three-storey building next to the Mount Pleasant. Now private homes, the whole building was once the Bear & Ragged Staff, shown here around 1910.

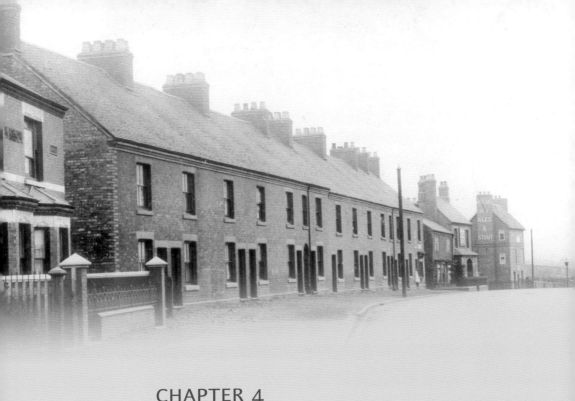

CHAPTER 4
Collycroft

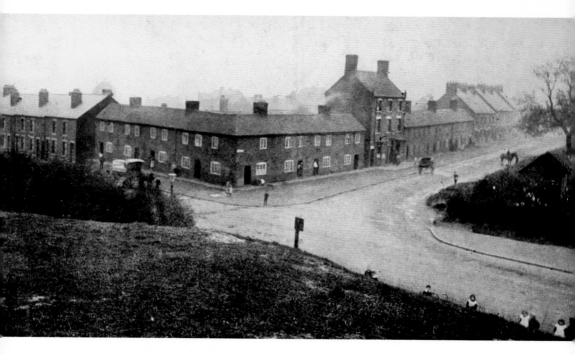

Marston Lane Corner: The Border

The pictures on page 37 show a line of terraced houses that are still there today, although they were only recently built when the postcard was produced in 1907. In the distance is The Rising Sun, shown below after it closed, and the Old House at Home, now Collycroft WMC. This page shows the corner, with the Miners Arms. The wooden fish and chip shop has Sam and Alice Richards using a coal fire to cook their products in the 1920s. When it closed in the 1960s, it was pushed over the edge of the clayhole behind it.

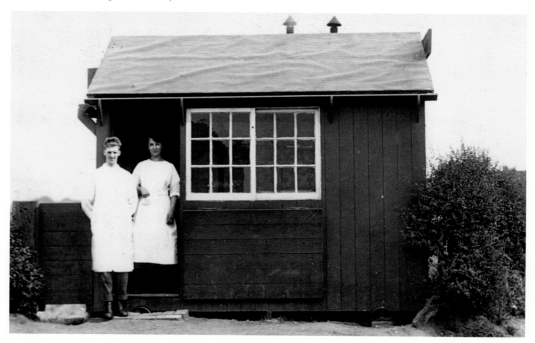

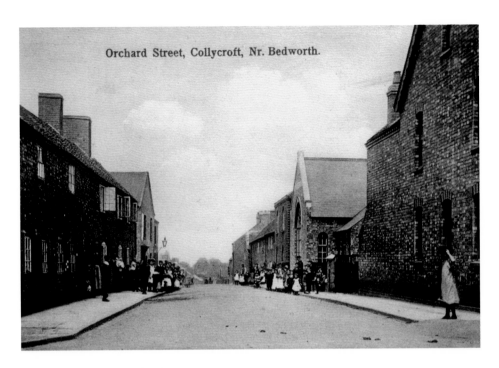

Orchard Street, Collycroft, Nr. Bedworth.

Marston Lane and Orchard Street

The extended triangular shape of old Collycroft (Nuneaton Road, Marston Lane and Orchard Street) goes back to medieval times, and is clearly shown on an open field plan from the early 1700s. The buildings in Orchard Street, shown here in 1907, were mostly late Victorian, but some were much earlier. The cottages shown below in Marston Lane in 1972 have gone but the row beyond was converted to one house.

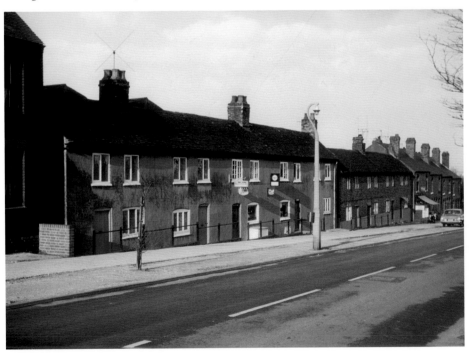

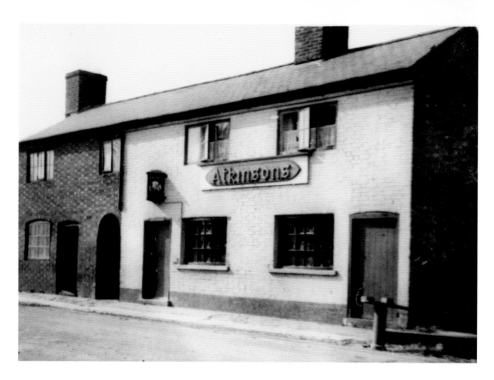

Orchard Street and the Old Goose

All over the country, we are losing hundreds of pubs every year, and with them much of the way of life they represented. The surviving ones struggle and the Old Goose has closed for good, to be developed as a small group of houses. The top picture shows the original pub, which probably grew out of its line of cottages before being enlarged and substantially rebuilt.

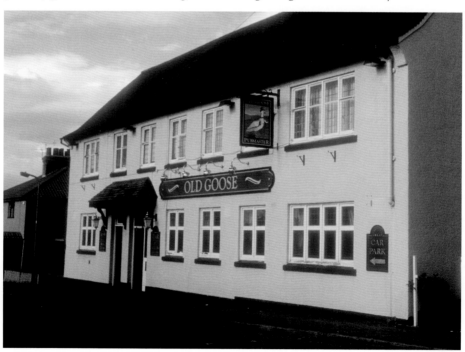

The Old Royal Oak

In the 1950s, this was the scene of a gruesome and tragic family murder. The old pub building was later pulled down and rebuilt. The bottom picture was taken from Orchard Street and looks across the allotments towards the back of the Old Royal Oak and Royal Oak Yard, where one group of cottages has just been demolished in 1981.

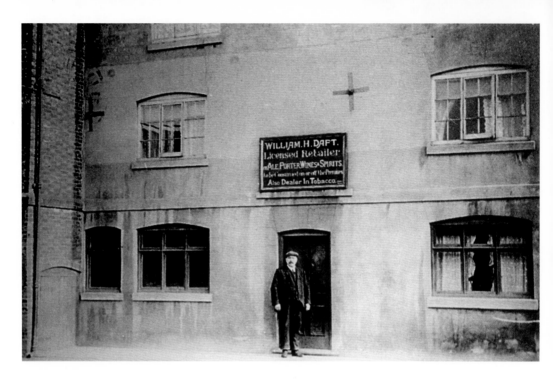

The Woolpack

William Daft was the publican when he was photographed in the early 1900s outside the Woolpack. It was close to the road but was rebuilt further back. In its prime, this was quite a distinguished looking building, demonstrated here by the inset of the main door.

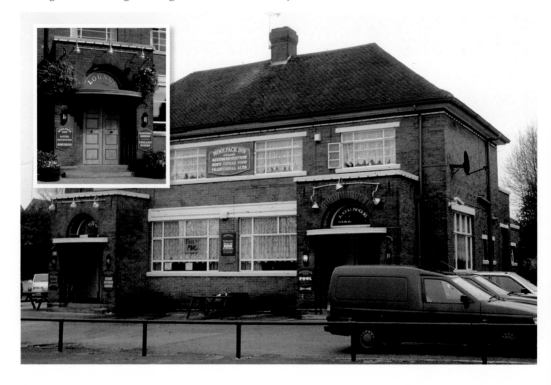

Collycroft School

The Chamberlaine Trust provided houses for their head teachers in 1885. This one is still there, though now converted to flats, as shown below, alongside the flats that were built on the Woolpack site. The top picture shows the empty school in 1971, which faced Orchard Street. It is behind the schoolhouse that later served as a restaurant, a clothes shop and a veterinary service.

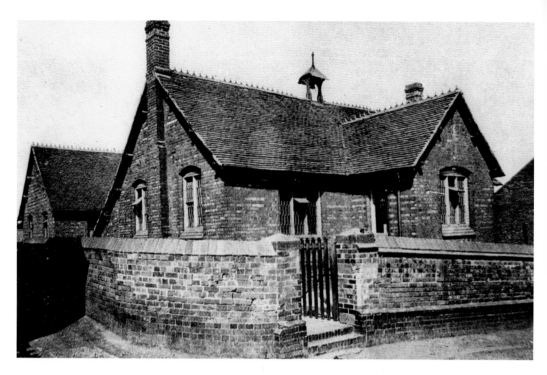

Orchard Street

Collycroft church school served the community for many years, but it eventually closed and children transferred to new buildings on a new site. It is shown here in 1911. After it was demolished, two houses were built on the site, shown below in February 1981. On the left, you can still see a small section of the old school wall.

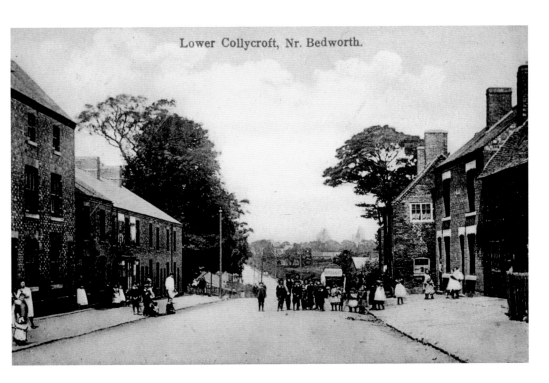

Lower Collycroft, Nr. Bedworth.

Nuneaton Road

The postcard dates from 1907 and was sold at the shop shown in the picture. Beyond are the open fields, pockmarked with mine workings, that link Collycroft and Griff. Children would not easily stand across the road today. The cottages shown close to the road below were demolished in the mid-1970s, soon after this picture was taken.

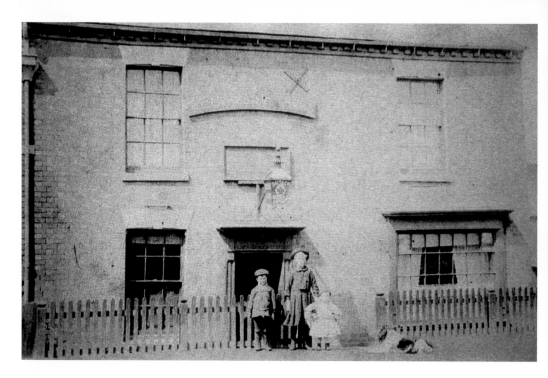

Nuneaton Road

These pictures give a glimpse of what old Collycroft looked like. The top picture shows the original Cricketers Arms around 1910. The lower picture shows the effects of mining subsidence. The cottages were a few yards up the road from the Cricketers, and were next door to the Old Royal Oak. We have no information about the girl sending her love from Collycroft.

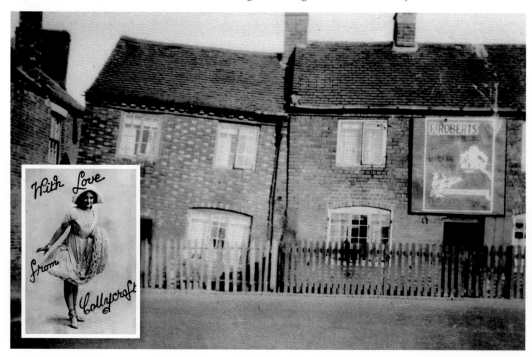

CHAPTER 5

Chapel Street
& King Street

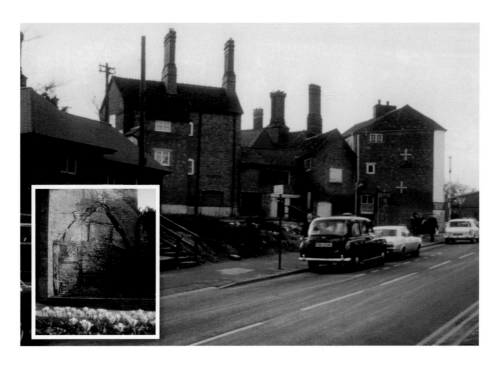

Top of Chapel Street

Every building in the top picture on page 47 has now gone. The Hit or Miss was on the corner of Leicester Street and Chapel Street. The off-licence was next to the Parsonage. Model Almshouse residents Abe and Ada are in the Roanne Garden, on the site of the shops. For several years, the jug was beautifully decorated. The pictures on this page show the same buildings from further down Chapel Street in 1971, and a Mick Shepperson painting looking down the street. The inset shows the old timber frame of the earlier cottage beneath the Nurse's House.

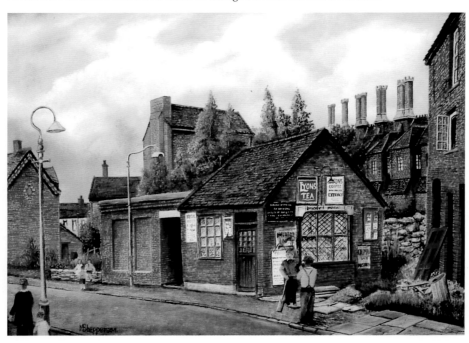

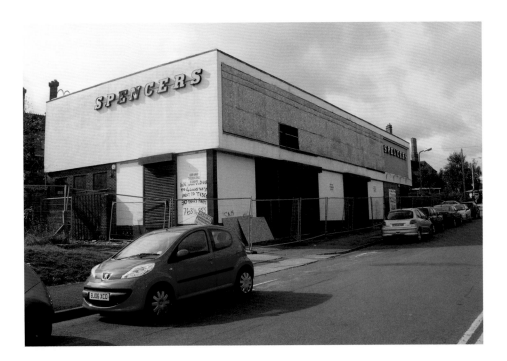

Chapel Street

A straight swap of buildings here. Spencers department store was a good bit of 1960s design, though it completely ignored the nearby Almshouses. Fifty years on, the planning department were more particular and insisted that the new care home, Chamberlaine Court, showed due deference to its near neighbour. It works well and won a Bedworth Society award for environmental excellence.

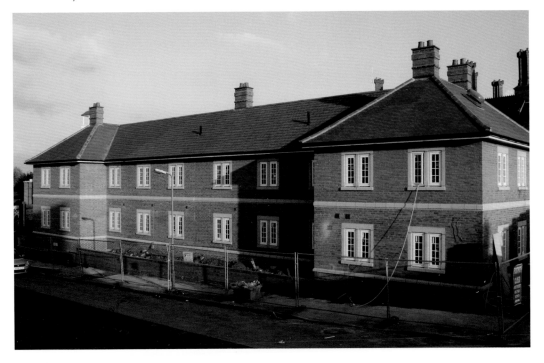

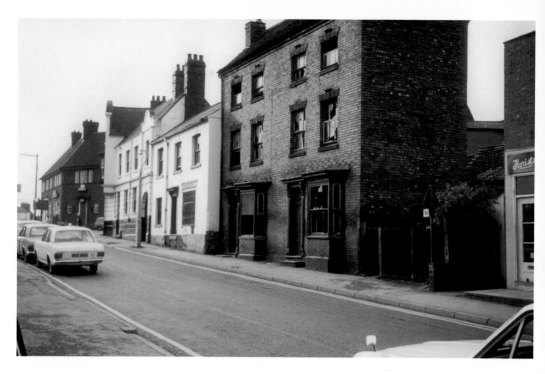

Chapel Street

These views are of the north side of Chapel Street. I think the three-storey brick building could have been restored. It has a style and a presence for a town centre. The bottom picture shows Grove Terrace shortly before they started adding, rendering and hiding the delightful patterned brickwork. Both date from 1971.

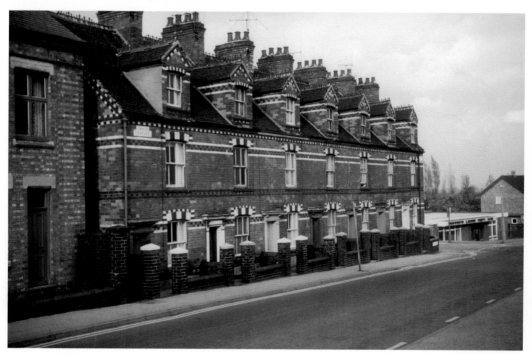

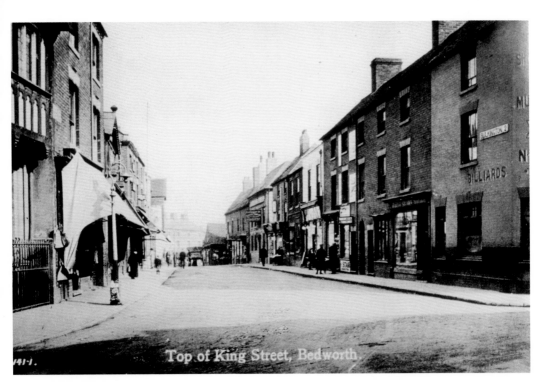

Top of King Street, Bedworth.

Top of King Street

Every building shown in the 1925 postcard has disappeared. The picture below was taken from the same spot in 2013.

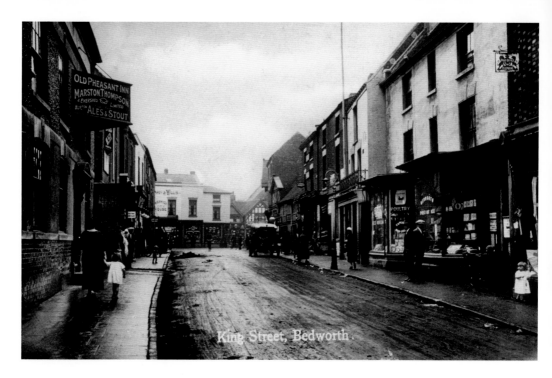

King Street, Bedworth.

Looking Up King Street

The top picture from 1925 shows the Old Pheasant on the left, and the post office on the right, next door but one to the first Liberal Club, political base for the legendary Billy Johnson MP in 1906. The 2013 version from the same spot speaks for itself, though it doesn't say much.

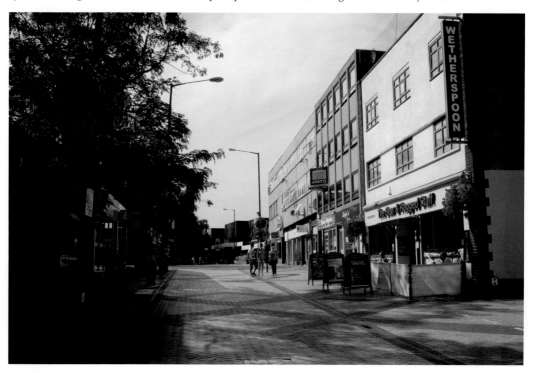

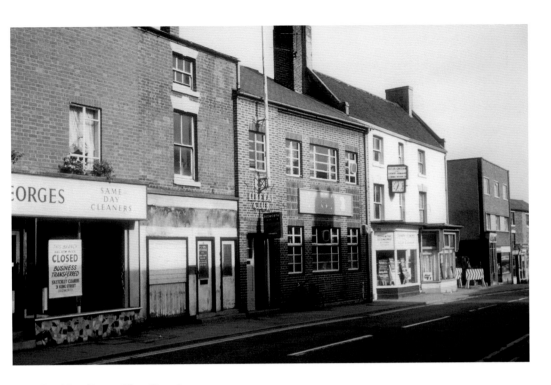

Looking Down King Street

The top picture shows the second Liberal Club in 1971, as well as the two bow-fronted shops seen opposite, not long before they were demolished. The present-day version shows the hideously out-of-proportion King's House, overshadowing the more interesting Royal Mail building, which at one time was the post office.

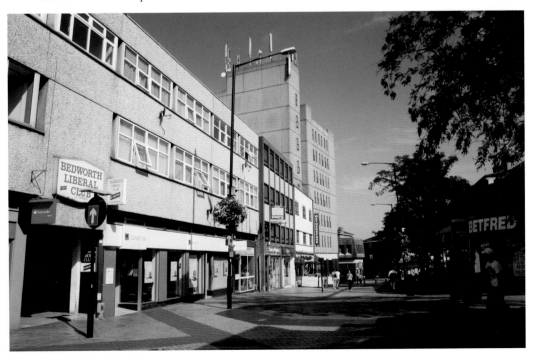

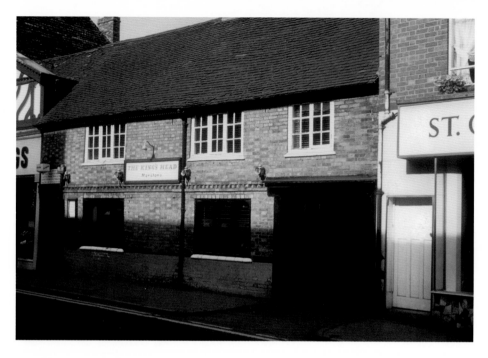

Two King Street Pubs

The King's Head was a lovely little place, shown here in 1971. It was much older than its surrounding buildings. At the rear, the stables were later used for boxing. For years, the pub was run by members of the Earl family. The Railway Tavern, on the corner of King Street and Rye Piece, was always known as the Corner Pin and was eventually officially renamed as such. This 1982 picture shows the original name.

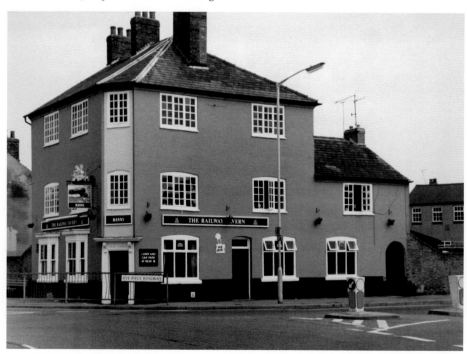

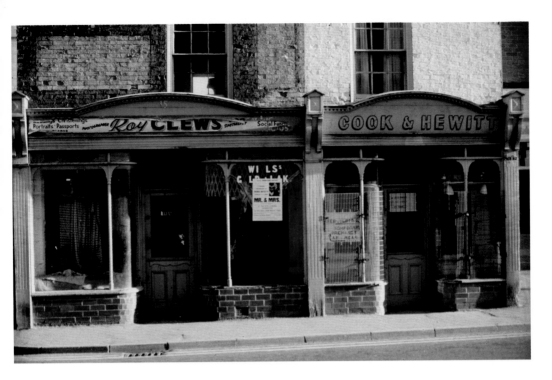

Looking Up King Street

The two shops above survived long after the rest of the street was redeveloped. This picture was taken in 1980. Hawkins estate agent is on the site now. Reg Stubbs and his family ran the toy shop, newsagent and general store for many decades. The inset shows him and his wife, and the picture below was taken from the roof of their shop in 1961.

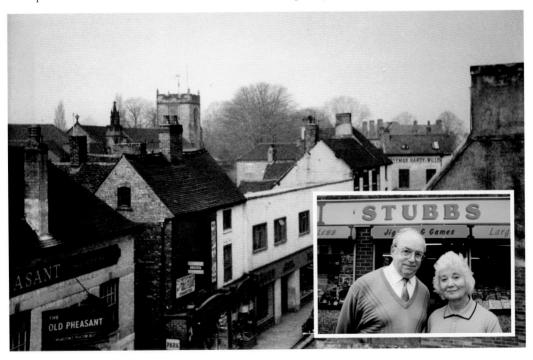

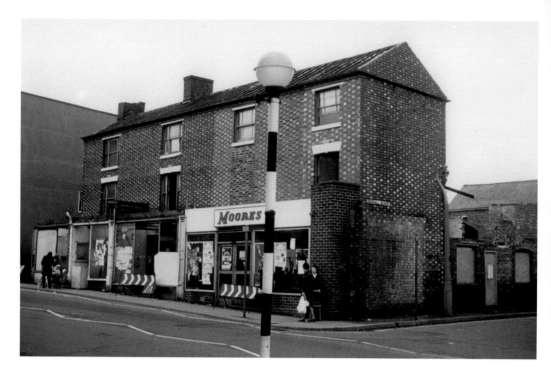

Croxall Street and the Dewis Family

The shops are shown in 1975, and demolition was already under way. Originally, the bakery was run by the Dewis family, and older people recall warming themselves against the bakery wall in Croxall Street. Before it closed, the bakery was run by Moores. Next door, a shop awaits demolition. It was run by another Dewis, and is shown below before the war.

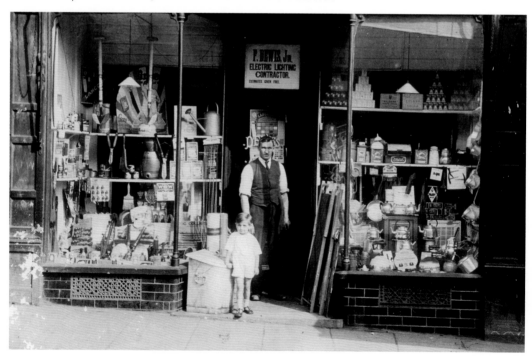

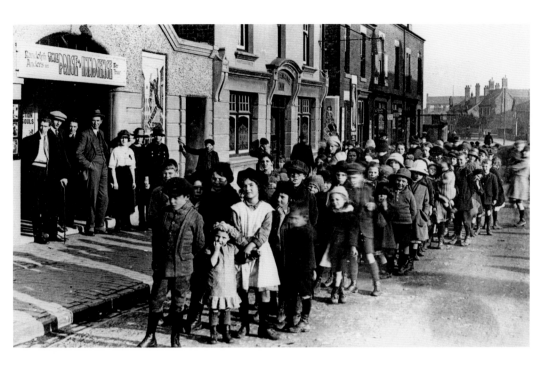

Chapel and Cinema

Children in the late 1920s are waiting to see a film at the Star cinema. The building, however, started life as a Primitive Methodist chapel, and the bricked in chapel windows are still visible. This is a sad corner of King Street. The British Queen, to the left of the picture, is closed. The Engine, one of several names the pub has had, was demolished soon after the picture below was taken, and the old chapel/cinema is no longer in use in 2014.

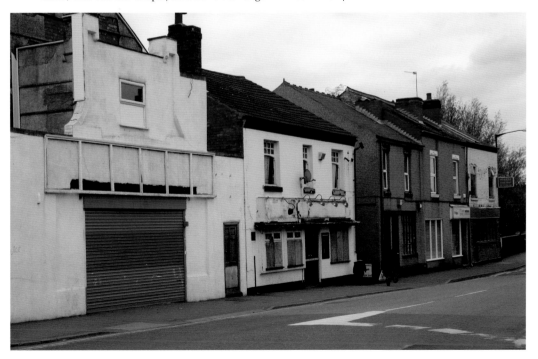

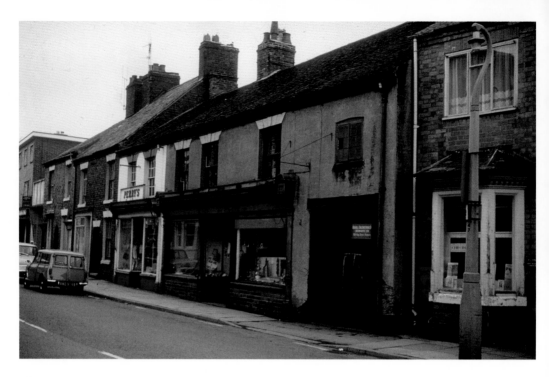

King Street

On the extreme left of the 1970 top picture is Bedworth WMC, often called the Little Club. It is still there, but every other building was demolished to make way for the Rye Piece Ringway. The 1979 picture below was just over the railway bridge. On the site now is a block of offices, opposite the station car park.

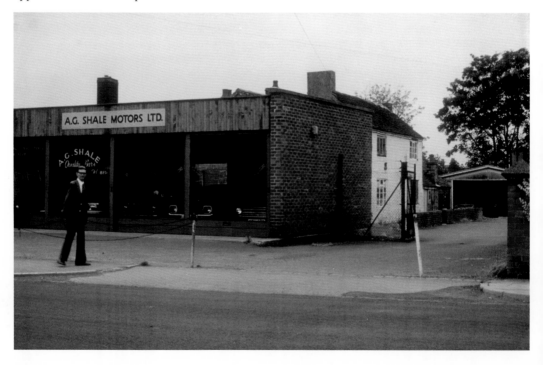

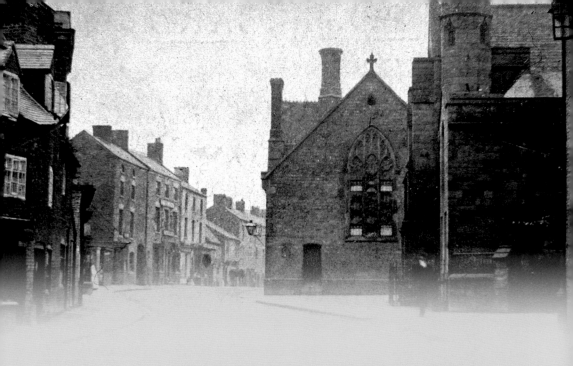

CHAPTER 6

High Street

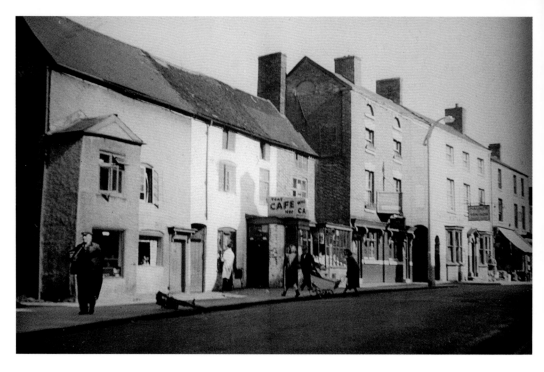

High Street

Pevsner refers to some distinguished-looking town houses in High Street. Needless to say they have all gone, but High Street does have the best modern buildings in the town. Page 59 shows the same scene in 1905 and 2013. This page shows more detail. Above, we see a 1950s shot of some of the three-storey buildings and the Civic Hall, which replaced them in 1973.

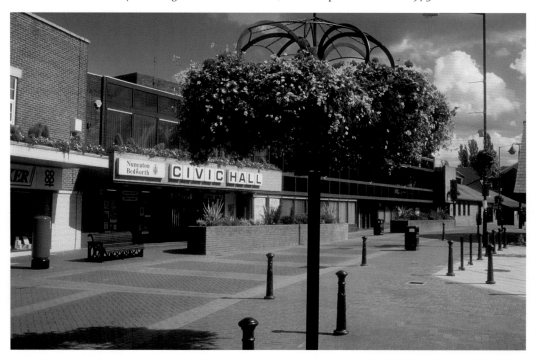

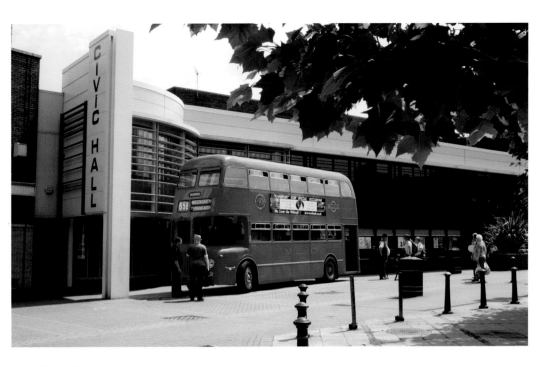

High Street

Early in the Millennium, the Civic Hall underwent an expensive revamp. The result grabs your attention and does make the building look more like a theatre than a conference centre. It is here with a restored Midland Red bus doing its duty for Northern Warwickshire Tourism. The bottom picture shows the buildings demolished to make way for the Civic Hall. I was on the site of the demolished Central School looking across at the Beehive, the Haunch of Venison, Ball's sweet shop and the library in 1970.

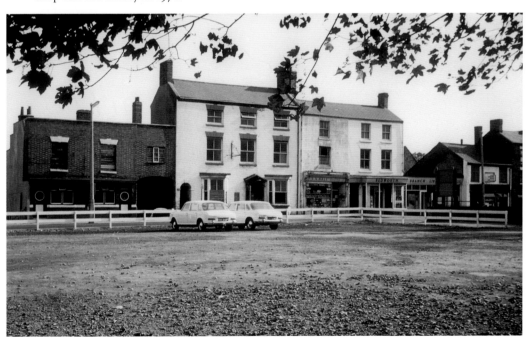

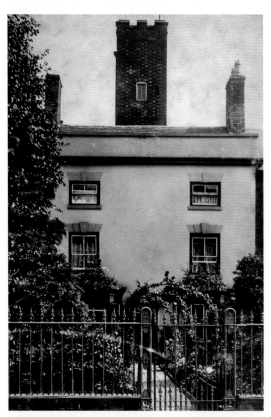

Tower House and Spitalfields

The Tower House stood where the Co-op now stands. It was owned by the Edmands family, with a weaving history in the town. The picture shows the house and lovely front garden before the war. Behind High Street was a run-down area known as Spitalfields, an elision from Hospital Fields, the area opposite the original 'Hospital' or Almshouses, adjacent to the parish church. The picture below shows part of Spitalfields or Spitaldicky in 1948, taken from Tower House.

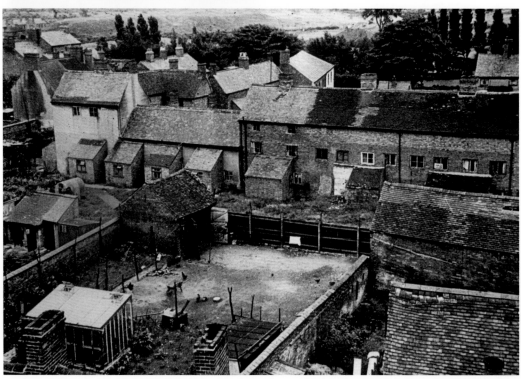

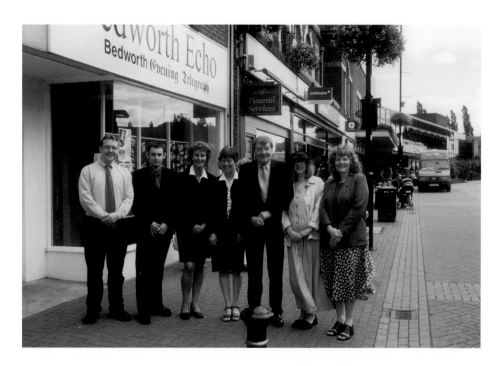

The *Bedworth Echo*

Bedworth is a proud town. People were delighted when Mort Birch and Alan Robinson started the *Bedworth Echo* in 1979. It fought some notable battles before being taken over. Mort Birch is shown above with staff outside the High Street Office in 2002. They are Matt Barron, John Harris, Lesley Harrison, Margaret Rose, Jane Stirling and Penny Cryer. A few years earlier, some microfiche films of early *Echo* numbers were presented to Bedworth Library. Alan Robinson is shown with Lynda Carnes, area librarian Chris Foster and photographer Ted Cotterill.

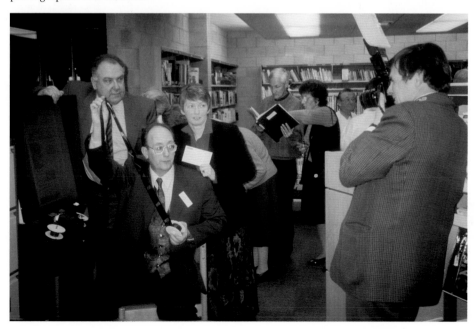

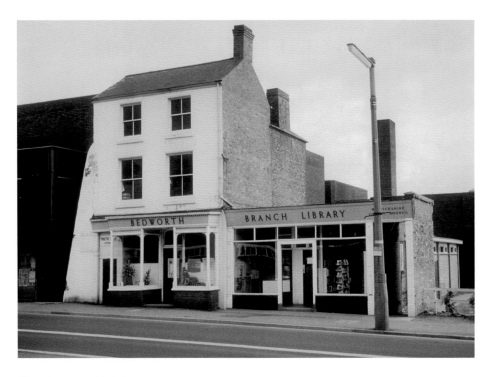

The Library in High Street

The library is shown here in 1976 next to the recently built Civic Hall. In the early 1900s, it was Dewis's pawnshop; later, it was Spencer's shoe shop. The picture below shows Mr and Mrs Hardiman. Their shop was next to the library and many children from the Central Schools remember popping in to buy sweets.

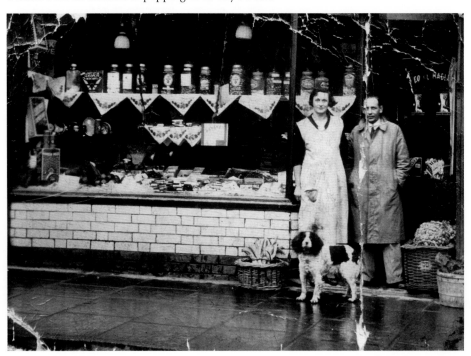

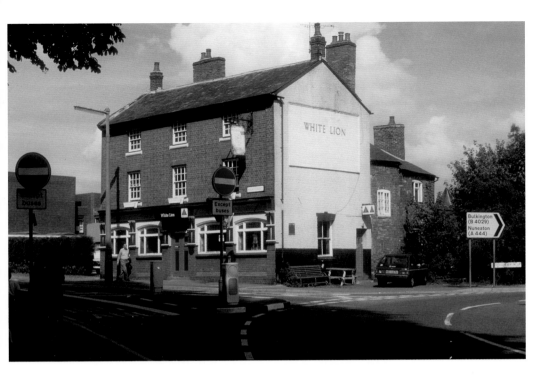

The White Lion in High Street

The White Lion stood on the corner of High Street and Rye Piece, opposite the cemetery entrance. Behind it, there was a large yard and a row of cottages leading to the Zion Baptist Chapel. Pubs were important social centres. The yard is being used in the lower photograph for the killing and distribution of a pig, owned jointly by some regulars at the pub.

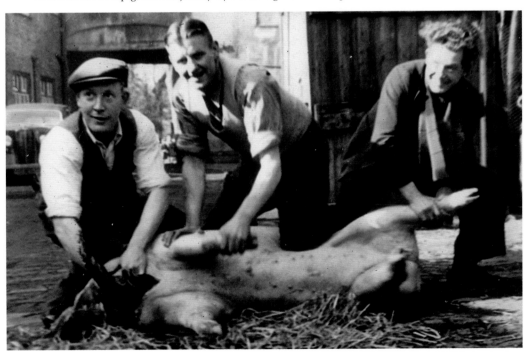

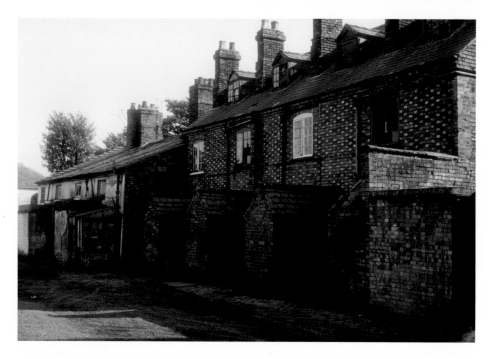

White Lion Yard

The cottages shown here in 1970 were awaiting demolition. Their fronts were alongside the pathway to Zion Baptist Chapel, a tiny bit of which is visible on the left of the picture. These houses were at the southern end of Spitalfields. The bottom picture shows the offices that replaced them and the pub, next to the new 1980s library. The lovely pub group (*inset*) dates from when the Boulstridge family ran it.

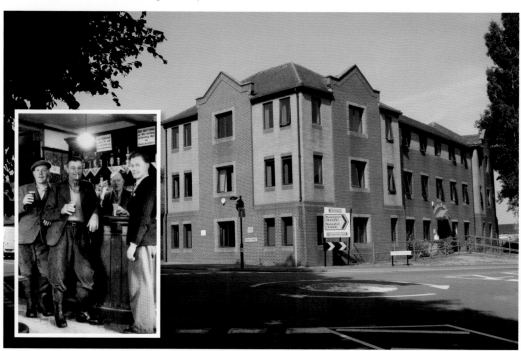

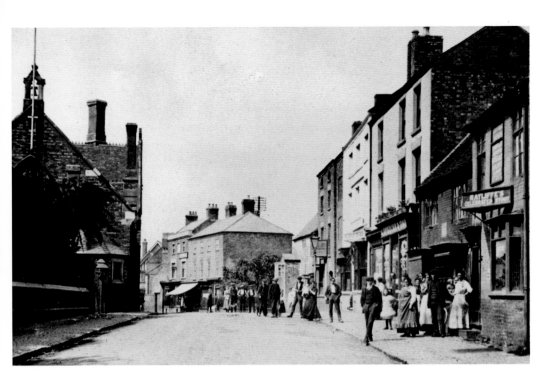

High Street

The top picture shows High Street in 1913. On the left is the Central School, with the Co-op in the distance, and Mr Spencer in the doorway of his shoe shop. On the right hand side of High Street at this time, there were six pubs or beerhouses. The lower picture shows the same view in 2013.

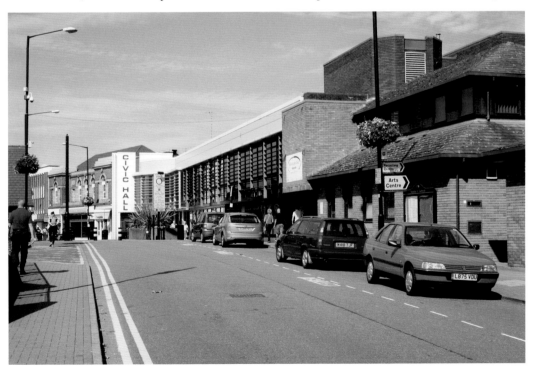

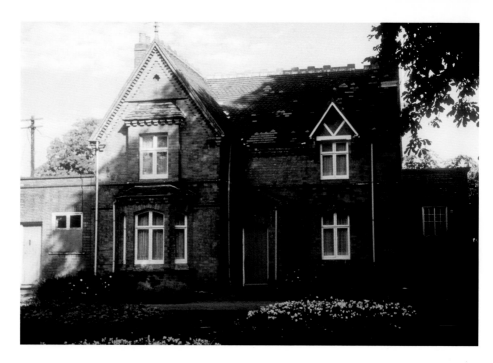

Official Buildings in High Street

The top picture shows the cemetery keeper's lodge before demolition in the late 1970s. The lovely Victorian villa was a sad loss, a needless demolition to satisfy the Home Office's need for a new police station, which is now inaccessible to the public. The Bosworth family provided three generations of cemetery keepers from here. The bottom picture shows the old Urban District Office in the mid-1970s.

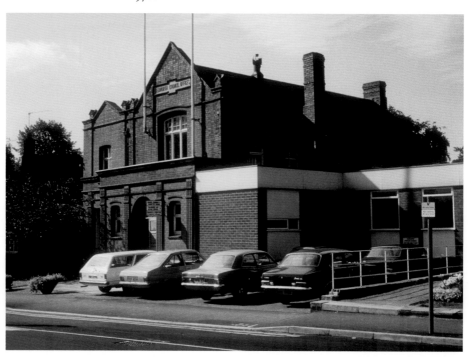

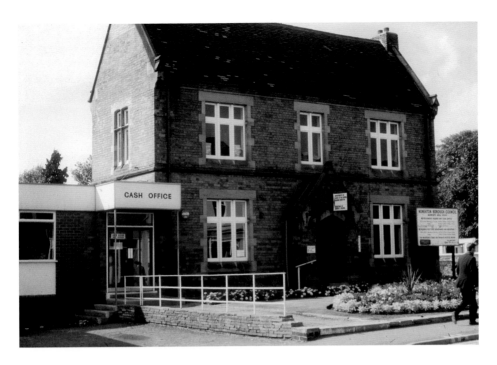

Official Buildings in High Street

Next to the old Bedworth UDC offices stood the head teacher's house for the Central Schools, shown here in 1978. The Bedworth Society tried to save this building in 1982 as an important part of the town's history. All three buildings on these two pages were demolished to make way for the new police station, actually a fine design by the now-extinct county architect's office.

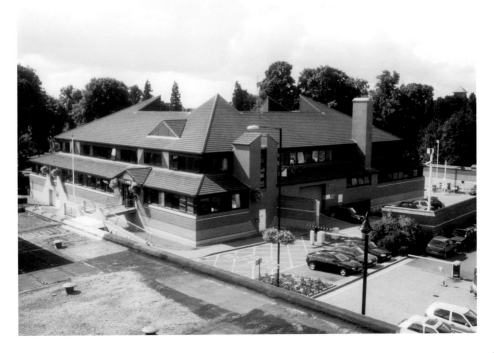

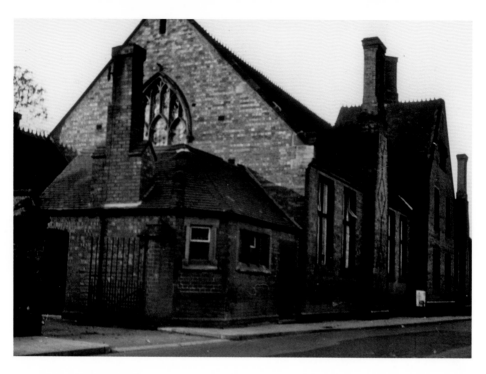

The Central Schools Site

These schools were built in 1845 on the site of the first Almshouses, which had been there since Nicholas Chamberlaine's death in 1715. They were demolished in the late 1960s when new schools were built a bit further out of town. A cheap and nasty health centre built on the site was replaced by the much better one shown below, with All Saints parish church (1890) in the distance.

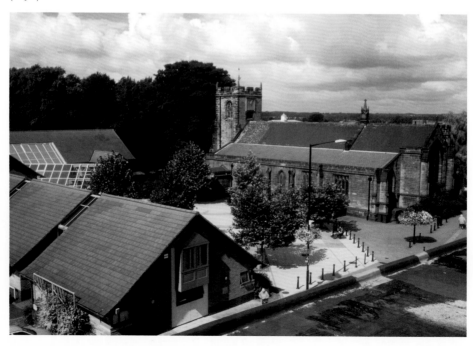

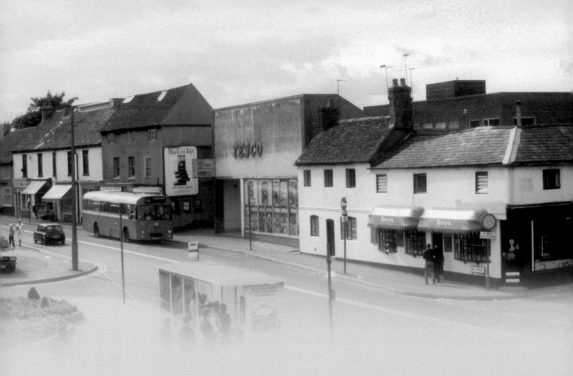

Mill Street &
Newtown Road

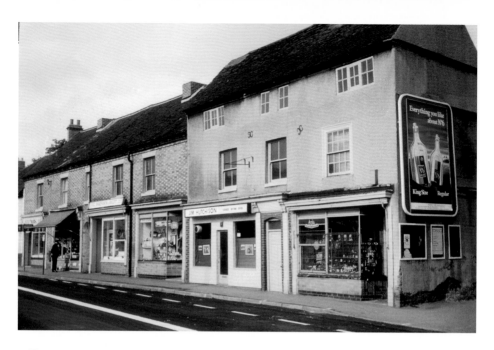

Mill Street

Page 71 shows the north side of Mill Street. The top picture shows the original Tesco store in August 1981, as they moved to their new store in Leicester Street. The shop is now a branch of Iceland. The lower picture shows Norman Terrace, now part of Tesco's car park. The pictures on this page show Sayers the jeweller in September 1978. This was an eighteenth-century ribbon weaving factory with long top shop windows. Fred Phillips is looking, in 1990, at the old windows, which had been left in a pile in the corner of the room.

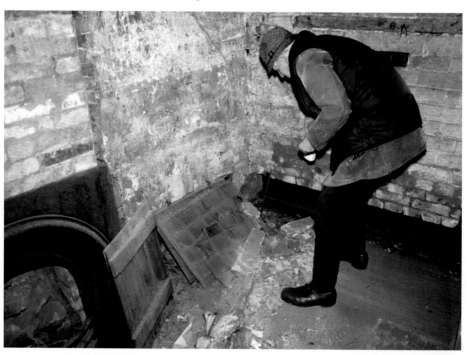

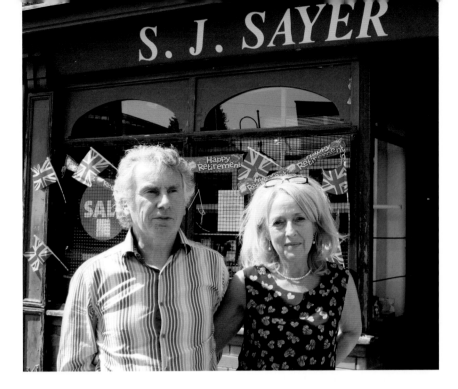

Family Business in Mill Street

The Sayer family has been in business for decades in Bedworth. This picture shows Mr and Mrs Sayer outside the jeweller's shop when he retired in 2012. Further down Mill Street, in Norman Terrace, was the sweet shop owned by Mr Bates, also a family business for several generations.

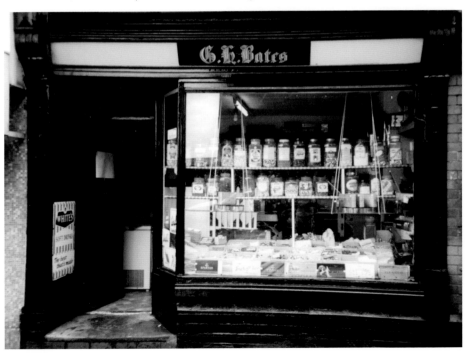

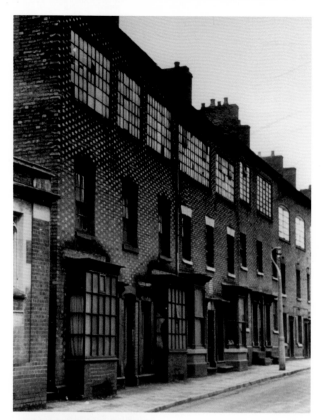

Mill Street Ribbon Weaving

The top picture shows the big top shop windows of ribbon weavers in 1948. These were built in the 1850s, and the top floor was large enough to take power driven Jacquard looms. The industry collapsed in 1860, but these buildings remained in Mill Street until the 1960s. The market was moved from its outdoor spot opposite the Almshouses to this purpose-built market hall on the site of ribbon weavers' houses.

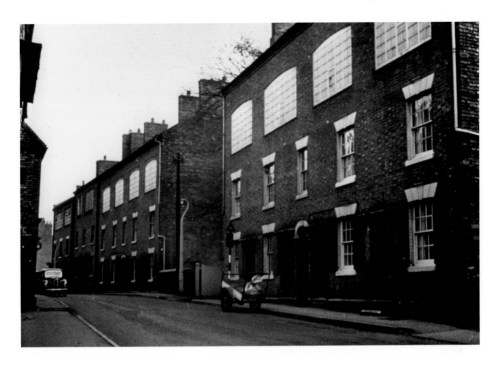

Mill Street Ribbon Weaving

The top picture shows the same line of ribbon weaving buildings as opposite, but from the bottom of Mill Street. Up the track between the two blocks was a large house belonging to businessman Brooke Peake, shown in the inset picture with his wife in a precarious three-wheeled motorbike. Shoppers Paradise claimed to be Britain's first hypermarket when it opened in the early 1970s. Part of it is visible behind the Anchor Inn, shown here in September 1978, and now part of the elaborate traffic crossing at the corner of Park Road.

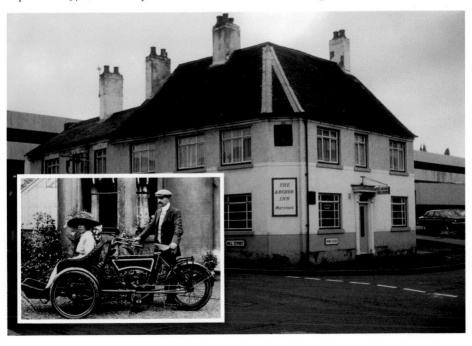

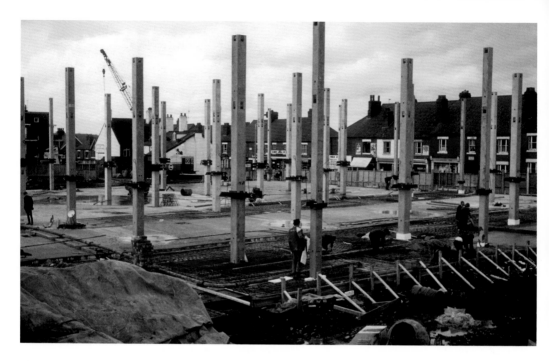

Shoppers Paradise

The large site on the corner of Park Road and Mill Street was acquired by local businessmen John Miller and Don Twigger, who built a successful supermarket there, moving from a rough-and-ready banana warehouse in Leicester Street where they consistently undercut traditional retailers at a time when Retail Price Maintenance was a political issue. Local people called the new store 'The Hyper'. It is shown here under construction in 1971, and in its concrete Brutalist reality in 1980.

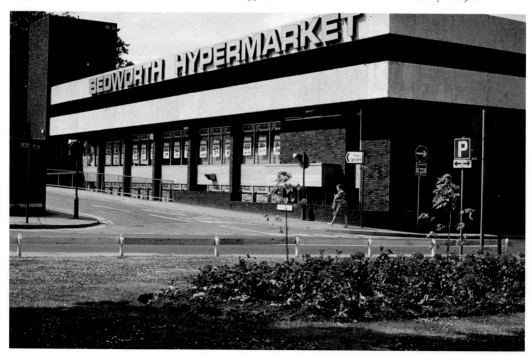

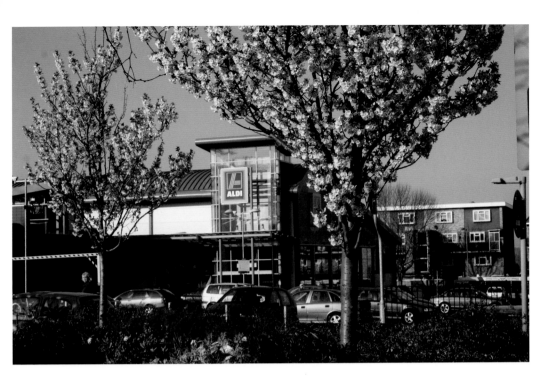

Mill Street Developments

The hypermarket went through several owners until it was eventually demolished in 2007, and the site developed by Aldi with a Home Bargains store alongside. The car park is in front of the store rather than on top of it. On the other side of Mill Street, Starkey's held out against Tesco's encirclement of the area, but eventually gave way and the whole of this site is now a car park.

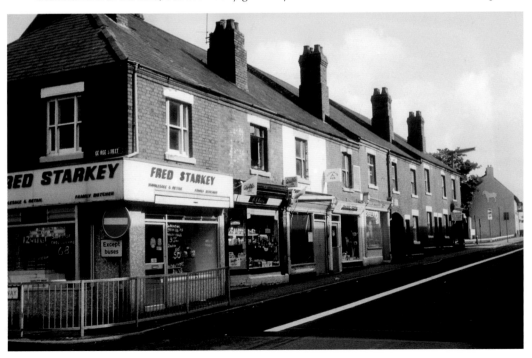

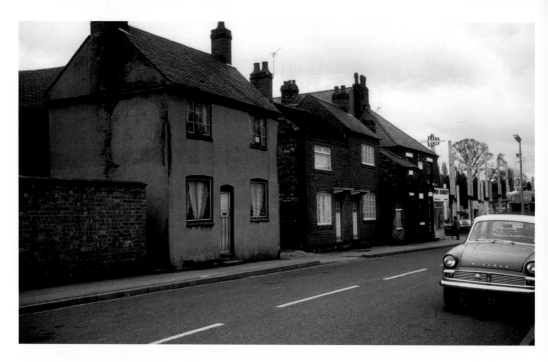

George Street and Mill Street

George Street, shown above in 1971, was once called Industry Yard. It was where the workhouse was situated. It is now an important through road for traffic either going to or past Tesco. All the property shown here is now the Tesco car park. The bottom picture shows a part of Mill Street that was demolished in the 1960s. The Castle pub is on the right. The decorated brick houses stood where the delivery lorries for Tesco turn off Mill Street.

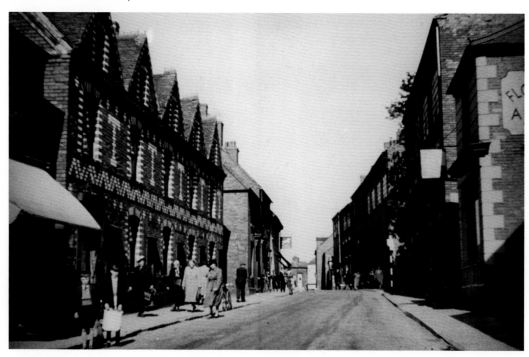

Newtown Road

Newtown Road in the days before we all had motor cars. Behind the tree on the right is now Toye, Kenning & Spencer, ribbon manufacturers. The houses down Thomas Street were built for workers in the factory, as were those in John Street that ran parallel to Thomas Street but 50 yards apart.

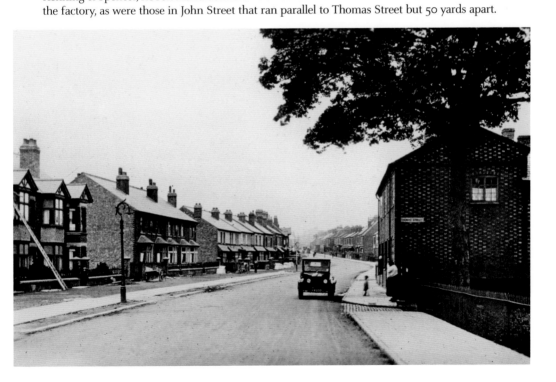

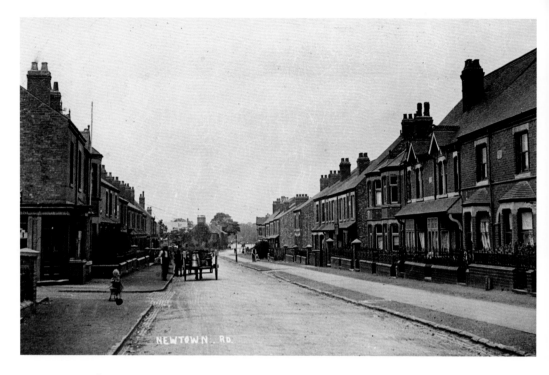

Newtown Road

The top picture dates from the First World War period, and shows milk being delivered from the churn. All the houses are still there. The lower picture is from further down Newtown Road, about where Arbury Road is to the left, Gallagher road to the right. It is around fifteen years later and shows the Queens Head, better known and now named as Alties.

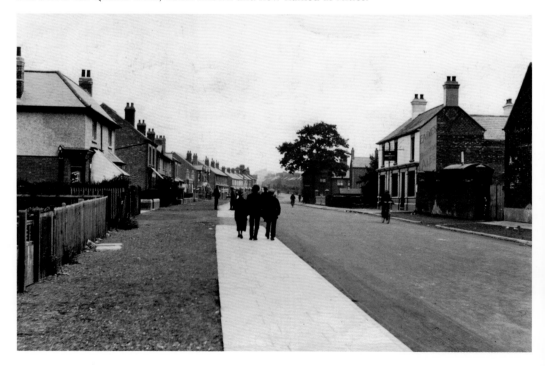

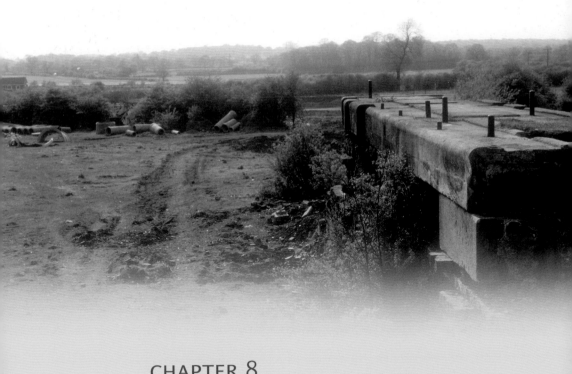

CHAPTER 8

Industry in Bedworth

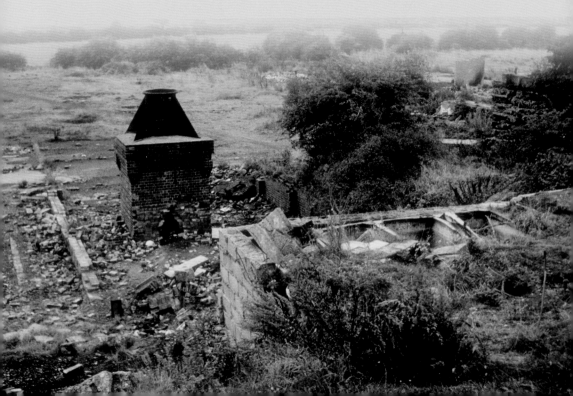

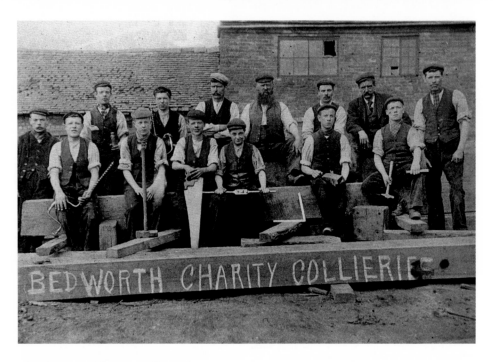

The Charity Colliery at Collycroft

The Charity Colliery was an important contributor to Bedworth's nineteenth-century prosperity, such as it was. Opened in the 1830s on Chamberlaine Charity land, it became an efficient mine. Its profits rebuilt the Almshouses in 1840. The remnants appear on page 81 and here. I photographed them in 1978, before the land was cleared to produce Sutherland Drive and its offshoots. The posed carpenters date from the First World War period and the token is from when Stanley Bros ran the mine.

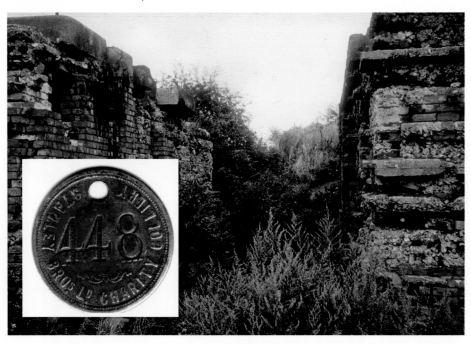

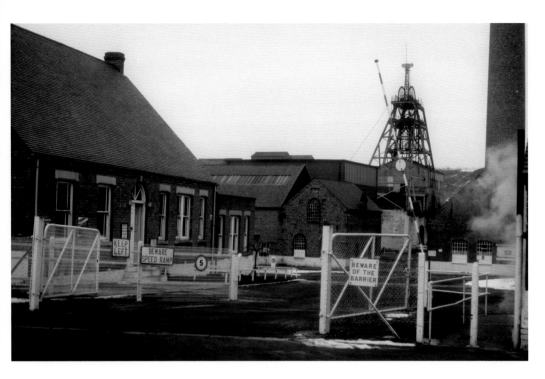

Newdigate Colliery
Mining and ribbon weaving have been the great employment providers in Bedworth's history. The Newdigate was sunk in 1898 and closed in February 1982. The buildings are shown here when it was about to close and a while later the chimney was demolished. I was able to record it.

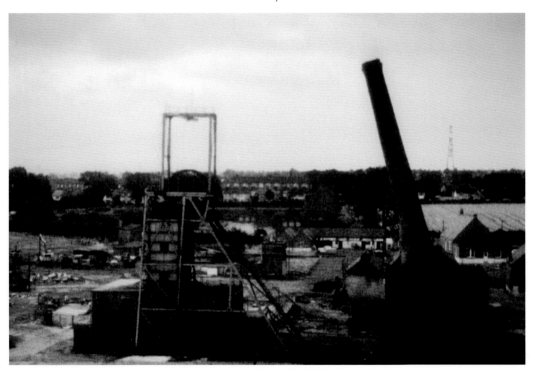

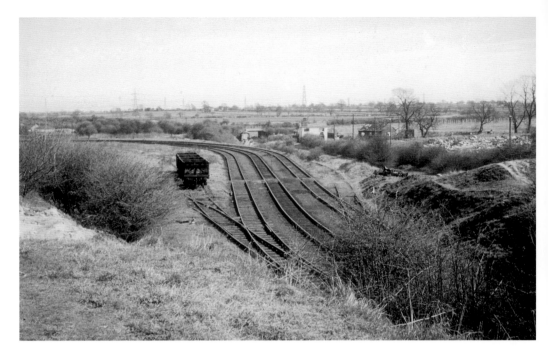

Newdigate Colliery

Mines had elaborate distribution systems for moving coal to customers. The top picture shows part of the system taking coal from Newdigate to the main railway lines. This was on the edge of the Miners' Welfare Park. A line also took wagons to an arm of the Coventry Canal for distribution by water. The inset shows Richard and Andrew Burton enjoying the snow in January 1979, not long before the mineral railway line closed.

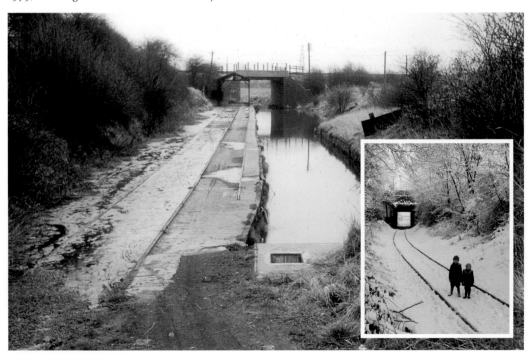

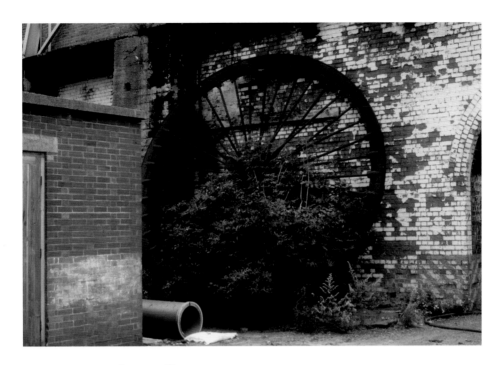

Last Days at Newdigate Colliery

This was the winding head wheel at Newdigate. Eventually, it was restored and placed on the highest spot in the Miners' Welfare Park in 1986, an inspired move by the Borough Council. The other picture shows members of The Bedworth Society in February 1982 on their first organised visit. They were allowed to go down the mine on its last weekend. The society is still running and has 220 members.

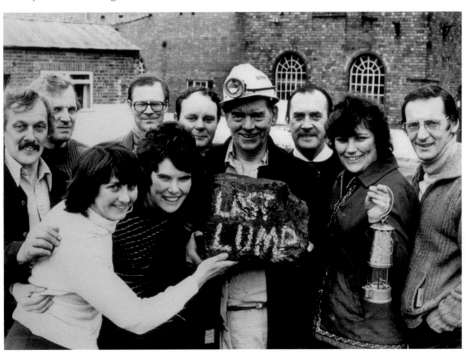

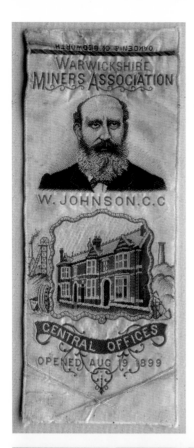

William Johnson MP

From a poor mining family in Chilvers Coton, William Johnson grew up and went to school in Collycroft. He worked in the silk mill but wanted to improve conditions for miners. He founded the Miners' Welfare Association, took up politics, became a county councillor and, in 1906, an MP. The silk ribbon was made to commemorate the opening of the Miners Offices, shown below, in Bulkington Road in 1899. Johnson should be a working-class hero but, in a sad show of historical ignorance, the local authority allowed part of the building to be demolished.

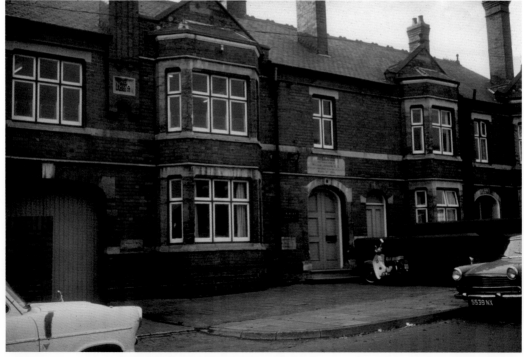

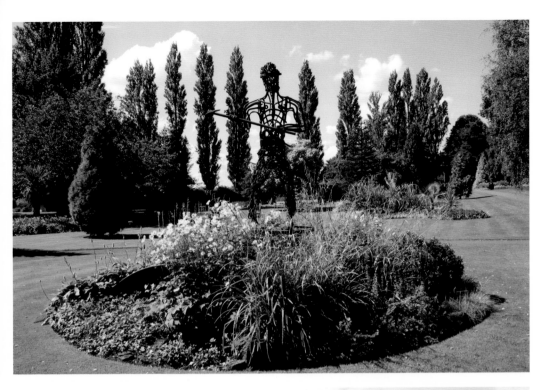

Remembering Collieries and Ribbon Weaving

The Miners' Welfare Park is on land purchased by the Miners' Welfare Association in the 1920s to give miners and their families space to relax. Having been taken over and enlarged by the local authority, in 2000 it won the Best Public Park in Britain award. Stella Carr's Miner in the Park, built by Ray Jones, is marvellous. The pile of ribbons in stone by Graeme Mitcheson shows scenes of Bedworth industrial history and is on the corner of King Street and Rye Piece.

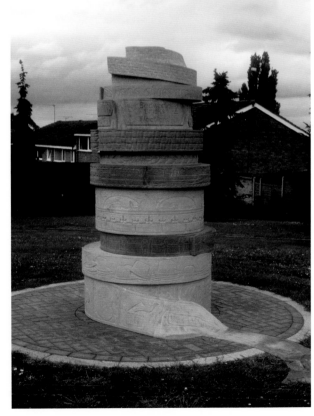

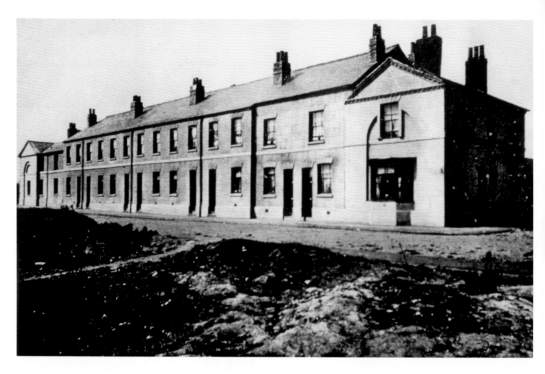

Ribbon Weaving

The top picture shows Collycroft Mill after it closed and was converted to housing around 1910. Catherine Ward Hall is on the site now. Toye, Kenning & Spencer have been weaving for 300 years. In these Newtown Road factories, they still make ribbons, regalia and hats, and use an original Jacquard loom.

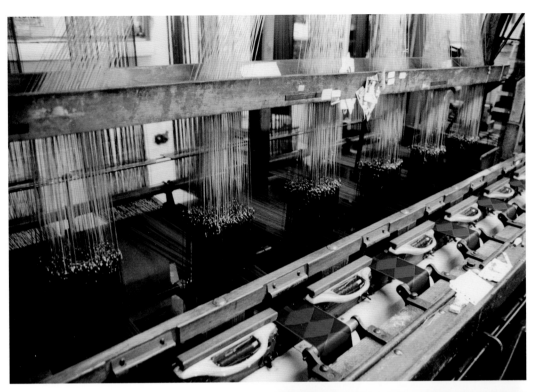

Ribbon Weaving

The top picture shows one of the Jacquard looms at Toye, Kenning & Spencer. This type of loom, introduced from France in the 1820s, revolutionised ribbon production and put many handloom weavers out of business. The picture below consists of Victorian silk ribbon produced in Bedworth, and reels of modern ribbon from Toye, Kenning & Spencer, on display in Bedworth Heritage Centre.

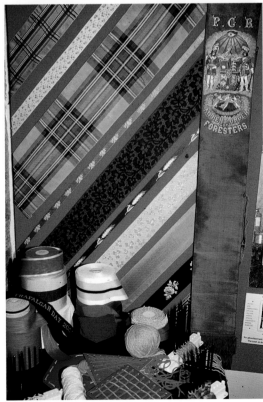

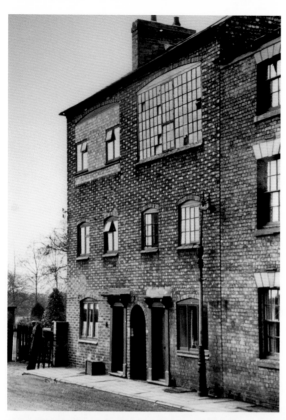

Ribbon Weaving

The houses shown here in Rye Piece, by the park entrance, are the only remaining nineteenth-century ribbon weaving topshops in Bedworth. The windows have been reduced in size, but their outline remains. The ladies in the bottom picture (Vivien Ramsden, Joyce Taylor, Anne Smith and Amie Wiberley) were part of an Heritage Lottery funded project on the history of ribbon weaving. They are in the top room of an old ribbon factory in Mill Street (see page 72).

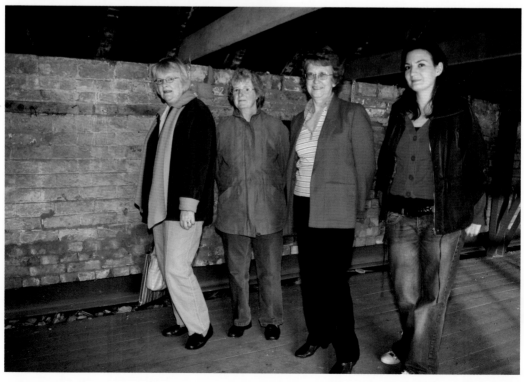

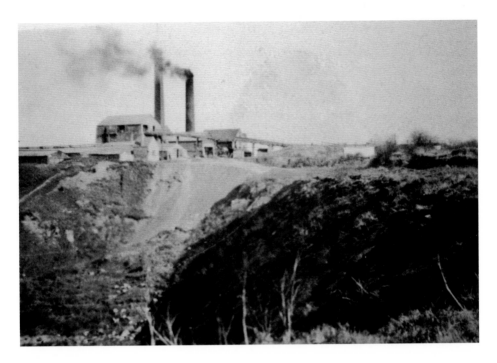

Brickmaking

Brickmaking was another mostly nineteenth-century local industry, often linked to a colliery, and there were numerous small brickyards in Bedworth. The top picture shows Downing's brickworks on the corner of Leicester Road and Marston Lane (now a park). The bottom picture shows an excavated site of Bedworth Brickworks, off Bulkington Road. The excavation took place before the new houses were built.

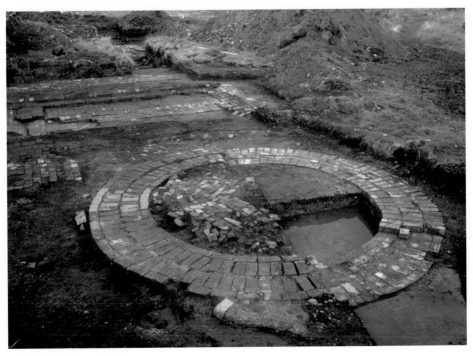

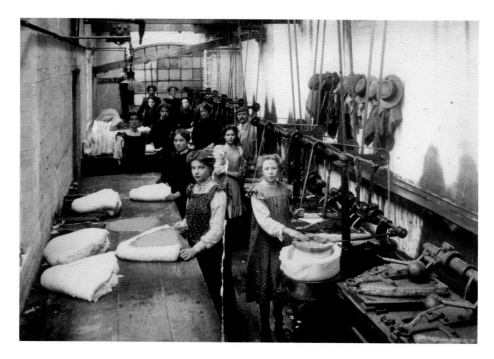

Hat-making

For about seventy years, hat-making flourished in Bedworth in factories run by Pickerings in Leicester Street and Woottons in Bulkington Road. These two photographs were taken in 1911 at Pickerings and show young girls in the forming process and men and boys in the dyeing and felting shop. Fashions changed, hat makers went out of business, but his 1943 Pickering military hat has survived in its owner's family.

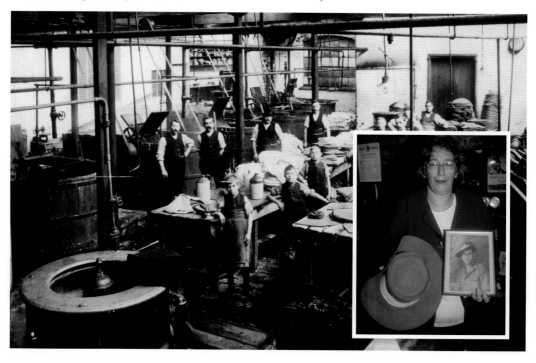

Hat-making

This site is now a housing estate called Hatters Court. Woottons made hats here for over fifty years, but before then it had been Paddy Hart's ribbon factory. Other parts of the site became Coventry Hood and Side Screen, a wonderful name for a firm. Later still, there were car repair workshops and light engineering on the site. The top picture was taken in 1911, the bottom one in 1971.

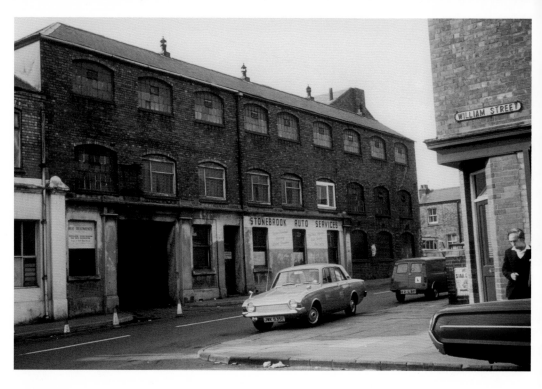

Hat-making

This was originally Paddy Hart's ribbon factory, then Wootton's hat factory. Here, it is in decline in the mid-1970s. The bottom picture was taken from the same spot after redevelopment.

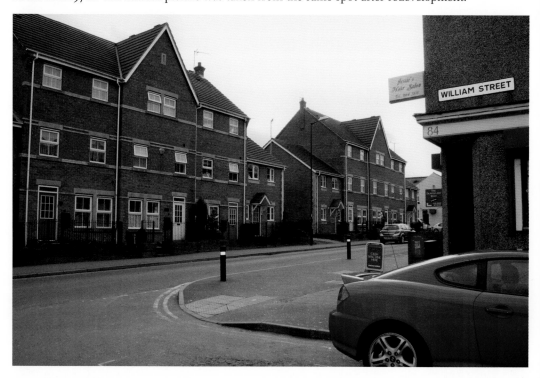

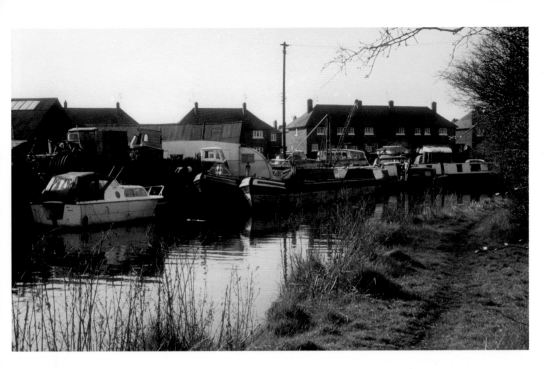

Furnaces

This rare photograph came from the collection of former headmaster W. H. Alexander. It shows furnaces belonging to the Bedworth Charity Iron & Coal Co. A rail line linked it to the charity colliery in Collycroft. It only produced iron for a few years in the 1870s, and this photograph was taken in the 1890s before it was demolished. It stood close to the Coventry Canal, behind the houses shown in the top picture of the boatyard in the 1970s.

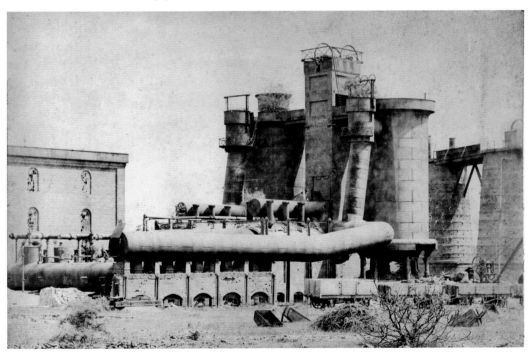

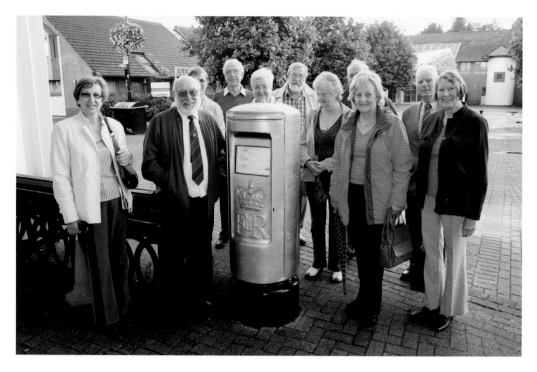

Nuneaton Probus Club
The picture above shows members of Nuneaton Probus Club and partners – the first group to visit the gold letterbox in High Street, Bedworth. It is in recognition of local boy Nick Skelton, gold medal winner in the 2012 London Olympics.

Acknowledgements

Most of the colour pictures, and all the modern photographs, were taken by me over the last forty-five years. Numerous people have contributed photographs over those years, and have allowed me to copy them and use them. I am truly grateful for their generosity, for without them none of these books would be possible. Friendships have also enriched my life and my collection. People like Ted Veasey, Fred Phillips, Gay Parker, Tony Davis, Arthur and Florrie Stevens, Madge Harrison, Ken Bosworth, Geoffrey Bourne, Geoff and Ronald Edmands, Geoff Hughes, Dorothy Olner, Susan Womersley, Eileen Baker and Maud Johnson added much valuable material. Sadly, all those have now passed away, but books like this one enable their contributions to be appreciated and to live on.

Since 2000, the Bedworth Society has run the Bedworth Heritage Centre and has mounted three or four displays about Bedworth's history every year since then; that is nearly fifty exhibitions. Bedworth people have supported it with information and loans of artefacts and photographs. I can only express heartfelt thanks to the numerous people who have contributed and thereby enlarged our knowledge of the history of the town.

BEDWORTH THROUGH TIME

Bedworth's long history, from its Saxon origins to its Domesday entry as a small farming settlement, and later to near extinction in the Black Death, has always been marked by hardship and poverty. Seventeenth-century hearth tax returns show it as the poorest village in Warwickshire. Hardship has given its inhabitants a distinctive and a gritty determination that marks them still, despite the changes of the last hundred years.

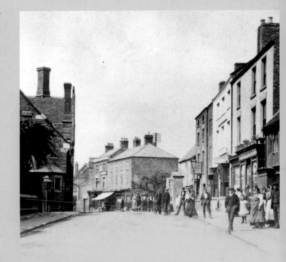

This fascinating selection of photographs traces some of the many ways in which Bedworth has changed and developed over the last century

The need for huge amounts of coal to drive the Industrial Revolution transformed the village into a town, and the coming of ribbon-weaving to the area changed its physical appearance. Squeezed by Coventry to the south and Nuneaton to the north, Bedworth remains proud of its achievements, of traditions and fierce independence. The photographs in this book show the extraordinary changes that have taken place over the last 120 years.

www.amberley-books.com

ISBN 978-1-84868-753-0

9 781848 687530

AMBERLEY PUBLISHING

£14.99

AMBERLEY PUBLISHING
The Hill, Stroud, Gloucestershire GL5 4EP